Papatango Theatre Compar
McPherson for the Finborou

C000116675

The World Premiere

EVERYDAY
MAPS FOR
EVERYDAY USE

by Tom Morton-Smith

FINBOROUGH | THEATRE

First performance at the Finborough Theatre: Tuesday, 4 December 2012

EVERYDAY MAPS FOR EVERYDAY USE

by Tom Morton-Smith

Cast in order of speaking

Behrooz al-Merreikh	**Moncef Mansur**
Maggie Radd	**Skye Lourie**
Kevin 'Kiph' Croaker	**Harry Lister Smith**
Richard Bleakman	**Michael Kirk**
Corinne Radd	**Cosima Shaw**
John Jones	**Michael Shelford**

The action takes place in and around Woking, 2012.

The performance lasts approximately 75 minutes.

There will be no interval.

Director	**Beckie Mills**
Designer	**Olivia Altaras**
Costume Designer	**Gabriella Slade**
Lighting Designer	**Neill Brinkworth**
Sound Designer	**Paul Gavin**
Assistant Director	**Dan Pick**
Production Manager	**Jane Arnold-Forster**
Stage Manager	**Emily Russell**
Casting Director	**Lucy Casson**
Associate Lighting Designer	**Miguel Vicente**
Assistant Stage Manager	**Tania Reed**
Assistant Production Manager	**Catherine Cooper**
Producer	**Chris Foxon**

Michael Kirk | Richard Bleakman
At the Finborough Theatre, Michael appeared in *Eden's Empire* (2006) and *The Lady's Not for Burning* (2007).
Theatre includes *Cash On Delivery* (The Mill at Sonning), *Once Bitten*, *The Charity that Began at Home* and *The Story of Vasco* (Orange Tree Theatre, Richmond), *The Great Highway* (Gate Theatre), *Born in Gilead* (Young Vic), *Jack and the Beanstalk* (Hackney Empire), *Amadeus* and *Macbeth* (Derby Playhouse), *My Fair Lady* (Theatre Royal Drury Lane), *Oliver!* (London Palladium), *Farm* (Greenwich Theatre), *Love's a Luxury*, *Abigail's Party*, and *Roughyheads* (Oldham Coliseum), *Great Expectations* (Walnut Street Theatre, Philadelphia), *How The Other Half Loves* and *Martin Chuzzlewit* (Nottingham Playhouse), *The Crucible*, *To Serve Them All My Days* and *Breezeblock Park* (Royal Theatre, Northampton), *Pal Joey* and *Romeo and Juliet* (Bristol Old Vic), *Pickwick Papers* and *Measure for Measure* (Everyman Theatre, Cheltenham), *Winner Takes All* and *Rabenthal* (Wolsey Theatre, Ipswich), *Victoriana* (New End Theatre, Hampstead) and *Present Laughter*, *Candida*, *Pygmalion*, *Murder by Misadventure*, *Twelfth Night* and *Ghosts* (National Tours).
Film includes *The Voice*, *Crack*, *Songbird* and *Lullabelle*.
Television includes *Casualty*, *London's Burning*, *EastEnders*, *Victoria and Albert*, *The Chief* and *North Square*.

Skye Lourie | Maggie Radd
Theatre includes *Donny's Brain* (Hampstead Theatre).
Film includes *The Holding*, *The Devil's Dosh* and *Guinea Pigs*.
Television includes *Hustle* and *The Pillars of the Earth*.

Moncef Mansur | Behrooz al-Merreikh
Trained at East 15.
Theatre includes *Qudz* (The Yard), *Enduring Song* (Bristol Old Vic), *The Observatory* (Edinburgh Festival) and *Yerma* (Helix Theatre).

Cosima Shaw | Corinne Radd
Theatre includes *The Dark Room* and *Summer Nights* (Tristan Bates Theatre).
Film includes *V for Vendetta*, *Ana Begins*, *Finding Joy* and *Papadopoulos and Sons*.
Television includes *Dr. Who*, *Zen*, *Stolen*, *Dirk Gently* and *Pete vs. Life*.
Radio includes *Trevor's World of Sport*.

Michael Shelford | John Jones
At the Finborough Theatre, Michael appeared in *Events While Guarding the Bofors Gun* (2012).
Theatre includes *Symphony* (Lyric Theatre, Hammersmith, and Latitude Festival), *Money in the Vaults* (Old Vic Tunnels), *The Stops* and *The Boy on the Swing* (Arcola Theatre), *Vox Pop* (Soho Theatre) and *Father/Son* (Etcetera Theatre).
Television includes *The Damnation of Darwin*, *Game of Thrones*, *Lewis*, *Mrs Biggs* and *Hollyoaks*.
Radio includes *Dracula*, *The Secret Pilgrim – The Complete Smiley*, *The Snowgoose*, *The Archers*, *We Outnumber You*, *Earls of the Court*, *Edith's Story*, *Slaughterhouse Five*, *Mountain of Light*, *Cinders* and *Hitched*.

Harry Lister Smith | Kevin 'Kiph' Croaker
Trained at the Guildhall School of Music and Drama.
Theatre includes *Posh* (Duke of York's Theatre) and *Hamlet* (Crucible Theatre, Sheffield).
Film includes *Madame Solario*.
Television includes *E20*, *Tom Brown's Schooldays* and *My Dad's the Prime Minister*.

Tom Morton-Smith | Playwright
Theatre includes *Salt Meets Wound* and *In Doggerland* (Theatre503), *Venison* (Hawth, Crawley), *Uncertainty* and *The Hygiene Hypothesis* (Latitude Festival), and a collaboration with composer Jon Nicholls on a play with music, *Blunderbuss* (The Theatre, Chipping Norton). Radio includes the episode 'Flesh' for BBC Radio 7's *Man In Black* series. Tom was writer-in-residence at Paines Plough in 2007-08. He is currently under commission to the Royal Shakespeare Company.

Beckie Mills | Director
At the Finborough Theatre, Beckie directed *I Was a Beautiful Day* (2009) which transferred to the Tron Theatre, Glasgow, and *Love on the Dole* (2010).
Theatre as Director includes *Romeo and Juliet* (Pendley Shakespeare Festival), *Hired* (Nabokov and Watford Palace Theatre), *Practice* (Royal Shakespeare Company Studio and Young Vic), *Heath/Cliff* (Royal Shakespeare Company Studio), *Cabaret*, *Alice in Wonderland*, *Fear and Misery in the Third Reich* (Bristol Old Vic Youth Theatre), *Over the Edge* (Bristol Zoo Gardens), *The End of the World as We Know It* (Lightship John Sebastian for Bristol Old Vic), *Write Here Write Now* (Bristol Old Vic Studio), *The Melancholy Hussar* (King's Head Theatre and Etcetera Theatre), *Cahoot's Macbeth* (King's Head Theatre) and *Alban*, a community opera (St Alban's Cathedral and St Alban the Martyr, Holborn). Theatre as Assistant Director includes *The Taming of the Shrew* (Royal Shakespeare Company), *Don John* (Royal Shakespeare Company and Kneehigh) and *Hedda Gabler* (Theatre Royal, Bath and National Tour).

Olivia Altaras | Designer
At the Finborough Theatre, Olivia designed *S27* (2009), *Love On The Dole* (2010) and *The December Man* (2011).
Read History of Art and English at The University of Leeds. Theatre as designer includes *Street Runners* (Blaze Festival), *Barbarians* (Tooting Arts Club), *The Merry Widow* (Folkwang Universitat der Kunst), *The Uncommercial Traveller*, *Space Invaders*, *The Night Chauffeur*, *Grey Goose Project*, *Under the Eiderdown*, *Haunted Park* and *Rose Bruford Symposium Festival* (Punchdrunk), *Gotcha* and *Fragments* (Riverside Studios), *A Moment of Silence* and *Ordinary Lads* (Etcetera Theatre).
Theatre as part of the design team includes *The Duchess of Malfi* (Punchdrunk), *Gamerunners* (Roundhouse Studios) and *The Masque of the Red Death* (BAC and Punchdrunk).

Gabriella Slade | Costume Designer
Trained at the Royal Welsh College of Music and Drama.
Theatre as Designer includes *People Like Us* and *Happy Never
After* (Pleasance London), *Beyond Borders* (Llanerchaeron
Estate Garden and Chirk Castle), *I Stay Here On My Bond*
(Shakespeare In A Suitcase, V&A), *A Month In The Country* and
The Merchant of Venice (Richard Burton Theatre). Theatre as
Costume/Set Supervisor includes *Revolution Cubana* (Wales
Millennium Centre), *Manifest Destiny* (King's Head Theatre),
Around The World In 80 Days and *The Mother* (The Scoop),
Sailing On (Edinburgh Festival), *Tripwires* (Phakama UK), *The
Duchess of Malfi* (Punchdrunk) and *The Beach* (National Theatre
Wales). Television includes *Upstairs Downstairs* and *Merlin*.

Neill Brinkworth | Lighting Designer
At the Finborough Theatre, Neill was Lighting Designer for *Fair*
(2005), *Accolade* (2011), *Fanta Orange* (2011), *Don Juan Comes
Back from the War* (2012) and *Outward Bound* (2012).
Theatre includes *In the Night Garden* (National Tour), *The
Seagull* (Arcola Theatre), *Fair*, *Tape*, *Step 9 of 12* and *Vincent
River* (Trafalgar Studios), *Agamemnon* (Cambridge Arts Theatre),
Seven Pomegranate Seeds (Oxford Playhouse), *Deptford Stories*
(National Theatre), *Six Men and A Poker Game* (Gridiron), *A
Square of Sky* and *In the Store Room* (The Kosh), *Romeo and
Juliet, Cats, Wedding Singer* and *Footloose* (Arts Educational
Schools), *Spangleguts* and *The Tinder Box* (London Bubble),
Blood Wedding and *Nicholas Nickleby* (Guildhall School of
Music and Drama), *The Handsomest Drowned Man* (Circus
Space) and *A Christmas Carol* (Southwark Playhouse). Opera
includes *Dido and Aeneas* and *Jephthe* (English Touring Opera),
Bridgetower (City of London and English Touring Opera) and
as Associate Lighting Designer includes *Ludd and Isis* (Royal
Opera House) and *Maria Stuarda* (Opera North). Forthcoming
productions include *The Tin Solider* (peut etre) and *Café Chaos*
(The Kosh).

Paul Gavin | Sound Designer
At the Finborough Theatre, Paul was Sound Designer for *Crash*
(2011) and *Through The Night* (2011).
Trained at RADA. Theatre includes *Sit and Shiver*, *Face Value*, *A
Mother Speaks*, *40* and *Brothers* (Hackney Empire), *The Famous
Compere's Police Dog Balls* (Duke of York's Theatre), *Lottie's
Journey* (New End Theatre, Hampstead), *Circus of Illusions*,
The Circus of Rock and Roll, *Sweet Charity*, *Spring Awakening*,
Cinderella and *Godspell* (Blackheath Concert Halls) and *Once
on this Island* (National Tour).

Dan Pick | Assistant Director
At the Finborough Theatre, Dan is Resident Assistant Director as part of a placement through the MFA in Theatre Directing at Birkbeck, University of London and recently assisted on *Hindle Wakes* (2012) and *Khadija is 18* (2012).
Studied at University College London. Directing includes *Macbeth* (Bloomsbury Theatre), *God: A Comedy by Woody Allen* (Pleasance Dome, Edinburgh Festival) and *Brick* (Garage Theatre). Assistant Directing includes *Ovid's Metamorphosis* (Bristol Old Vic Theatre School). Film and Television includes *The Wolfman*, *House of the Rising Sun* and *La Mer*.

Jane Arnold-Forster| Production Manager
At the Finborough Theatre, Jane was Production Manager on *A Life* (2012) and *Foxfinder* as part of the 2011 Papatango New Writing Festival.
Production Management includes *Ignorance* (Hampstead Theatre), *La Bohème* (Charing Cross Theatre), *The Only True History of Lizzie Finn* (Southwark Playhouse), *Brimstone and Treacle* (Arcola Theatre), *Acante et Cephise* (Bloomsbury Theatre), *Lagan* (Ovalhouse) and *Don Giovanni* (Soho Theatre).

Emily Russell | Stage Manager
At the Finborough Theatre, Emily was Stage Manager for *The Drawer Boy* (2012) and *Cornelius* (2012), and Operator for *The Sluts of Sutton Drive* (2012).
Trained at Royal Holloway, University of London in Drama and Theatre Studies. Theatre includes *HAVERFORDWEST* (theSpace @ Surgeon's Hall) and *Something Good* (Firestation Arts Centre).

Lucy Casson | Casting Director
At the Finborough Theatre, Lucy is currently one of the Resident Casting Directors and has cast *Through the Night* (2011), *Cornelius* (2012), *The Sluts of Sutton Drive* (2012), *The Fear of Breathing* (2012), *Autumn Fire* (2012) and *Merrie England* (2012).
Other theatre includes *The Seagull* (Southwark Playhouse) and *The Art of Concealment* (Riverside Studios). Film includes *Tested* and *The Dark Road* starring Con O'Neil (both as Casting Assistant).

Miguel Vicente | Associate Lighting Designer
At the Finborough Theatre, Miguel was Lighting Designer for *Through the Night* (2011), *The Fear of Breathing* (2012), *Passing By* (2012), *Barrow Hill* (2012), *Merrie England* (2012) and *Autumn Fire* (2012).

Trained at the London Academy of Music and Dramatic Art (LAMDA).

Theatre includes Laura Wade's *Other Hands* (National Tour), *Missing* (Tristan Bates Theatre), *Normal?* (Ovalhouse and LOST Theatre), *Miss Julie* (Theatro Technis), *The Happy Prince* (Little Angel Theatre), and *Chapel Street* (Old Red Lion Theatre).

At LAMDA, Miguel was the Lighting Designer for *The Last Days of Judas Iscariot*, *Hedda Gabler*, and *Kindertransport*.

Tania Reed | Assistant Stage Manager
Trained at RADA. Theatre includes *The President and the Pakistani* (Waterloo East Theatre), *London in Harmony* (London Palladium) and *Don Giovanni* (Opera Holland Park.) Television as Art Director includes *Parade's End*, *The Crimson Petal and the White*, *Sadie J* and *Holby City*. Film as Art Director includes *The King is Dead*, *Tribe*, *Annabelle's Tea Party* and *David is Dying*.

Catherine Cooper | Assistant Production Manager
At the Finborough Theatre, Catherine was Production Assistant on *The Fear of Breathing* (2012).

Theatre includes *Cuffed* (White Bear Theatre), *Only Human* (Theatre503), *Can't Pay Won't Pay*, *Pillow Talk*, *The Weather Today*, *Gabriel*, *A Night Of Fairytales*, *Heroes*, *Good Will Unwilling* (St Mary's University, Twickenham), *Visions and Delusions* (Strawberry Hill House) and *All Star Talent* (Rose Bruford College).

Chris Foxon | Producer
At the Finborough Theatre, Chris produced *The Fear of Breathing* (2012) and *Vibrant 2012 – A Festival of Finborough Playwrights* (2012), and was Assistant Producer for *Don Juan Comes Back From The War* (2012).

Read English at Oxford University and trained at the Central School of Speech and Drama on an AHRC Scholarship. Productions include *Old Vic New Voices 24 Hour Plays* (Old Vic), *The Madness of George III* (Oxford Playhouse), *Grave Expectations* (Compass Theatre, St Albans South Signal Box and South Hill Park) and *Looking After The Pooters* (Canal Cafe Theatre). Theatre as Assistant Producer includes *On The Threshing Floor* (Hampstead Theatre), 'Endless Poem' as part of *Rio Occupation London* (BAC, People's Palace Projects and HighTide Festival Theatre) and *Mudlarks* (HighTide Festival Theatre, Theatre503 and Bush Theatre).

Production Acknowledgements
With thanks to Adam Seddon, Dominique Neville, Ryan Hurst, Hayley Kaimakliotis, the Workspace Group and Hannah Jenner.

Papatango was founded by Matt Roberts, George Turvey and Sam Donovan in 2007. The company's mission is to find the best and brightest new talent in the UK with an absolute commitment to bring their work to the stage. 2009 saw the launch of their first Papatango New Writing Competition, which each year has gone from strength to strength.

Following the huge success of the Papatango New Writing Festival 2011 in partnership with the Finborough Theatre which saw unprecedented press acclaim for the sell-out production of the winning play, Dawn King's *Foxfinder*, the partnership between Papatango and one of London's leading new writing venues, the multi-award-winning Finborough Theatre, continues...

This year's competition saw 700 entries from all over the world.

This year's judges included Con O'Neill (Actor), Dawn King (Playwright), Colin Barr (BBC Director and Producer), Tamara Harvey (Director), Blanche McIntyre (Director), Neil McPherson (Artistic Director of the Finborough Theatre), Francis Grin (Literary Manager of the Finborough Theatre) and Tanya Tillett (Literary Agent, The Rod Hall Agency).

Press on *Foxfinder*

Time Out Critics' Choice
The Guardian Critics' Choice
★ ★ ★ ★ ★ *WhatsOnStage*
★ ★ ★ ★ *The Telegraph*
★ ★ ★ ★ *The Guardian*
★ ★ ★ ★ *The Independent*
★ ★ ★ ★ *Evening Standard*
★ ★ ★ ★ *Exeunt*
★ ★ ★ ★ *Spoonfed*
★ ★ ★ ★ *Time Out*
One of *The Independent*'s Top Five Plays of 2011
Nominated for the OffWestEnd Award for 2011 for Best New Play

FINBOROUGH | THEATRE

"An even more audacious and successful programme than ever in 2012, West London's tiny, unsubsidised Finborough Theatre is one of the best in the entire world. Its programme of new writing and obscure rediscoveries remains "jaw-droppingly good".
Time Out / The Hospital Club

"A disproportionately valuable component of the London theatre ecology. Its programme combines new writing and revivals, in selections intelligent and audacious." *Financial Times*

"A blazing beacon of intelligent endeavour, nurturing new writers while finding and reviving neglected curiosities from home and abroad." *The Daily Telegraph*

Founded in 1980, the multi-award-winning Finborough Theatre presents plays and music theatre, concentrated exclusively on new writing and genuine rediscoveries from the 19th and 20th centuries. The Finborough Theatre remains unfunded by any public body, and our most significant subsidy comes from the distinguished actors, directors, designers and production team who work with us for minimal remuneration. We aim to offer a stimulating and inclusive programme, appealing to theatregoers of all ages and from a broad spectrum of the population. Behind the scenes, we continue to discover and develop a new generation of theatre makers – through our vibrant Literary team, our internship programme, our Resident Assistant Director Programme, and our partnership with the National Theatre Studio providing a bursary for Emerging Directors.

Despite remaining completely unsubsidised, the Finborough Theatre has an unparalleled track record of attracting the finest creative talent, as well as discovering new playwrights who go on to become leading voices in British theatre. Under Artistic Director Neil McPherson, it has discovered some of the UK's most exciting new playwrights including Laura

Wade, James Graham, Mike Bartlett, Sarah Grochala, Jack Thorne, Simon Vinnicombe, Alexandra Wood, Al Smith, Nicholas de Jongh and Anders Lustgarten.

Artists working at the theatre in the 1980s included Clive Barker, Rory Bremner, Nica Burns, Kathy Burke, Ken Campbell, Jane Horrocks and Claire Dowie. In the 1990s, the Finborough Theatre became known for new writing including Naomi Wallace's first play *The War Boys*; Rachel Weisz in David Farr's *Neville Southall's Washbag*; four plays by Anthony Neilson including *Penetrator* and *The Censor*, both of which transferred to the Royal Court Theatre; and new plays by Richard Bean, Lucinda Coxon, David Eldridge, Tony Marchant, Mark Ravenhill and Phil Willmott. New writing development included the premieres of modern classics such as Mark Ravenhill's *Shopping and F***king*, Conor McPherson's *This Lime Tree Bower*, Naomi Wallace's *Slaughter City* and Martin McDonagh's *The Pillowman*.

Since 2000, new British plays have included Laura Wade's London debut *Young Emma*, commissioned for the Finborough Theatre; James Graham's *Albert's Boy* with Victor Spinetti; Sarah Grochala's *S27*; Peter Nichols' *Lingua Franca*, which transferred Off-Broadway; Anders Lustgarten's *A Day at the Racists*; Dawn King's *Foxfinder*; and West End transfers for Joy Wilkinson's *Fair*; Nicholas de Jongh's *Plague Over England*; and Jack Thorne's *Fanny and Faggot*. The late Miriam Karlin made her last stage appearance in *Many Roads to Paradise* in 2008. Many of the Finborough Theatre's new plays have been published and are on sale from our website.

UK premieres of foreign plays have included Brad Fraser's *Wolfboy*; Lanford Wilson's *Sympathetic Magic*; Larry Kramer's *The Destiny of Me*; Tennessee Williams' *Something Cloudy, Something Clear*; the English premiere of Robert McLellan's Scots language classic, *Jamie the Saxt*; and three West End transfers – Frank McGuinness' *Gates of Gold* with William Gaunt and John Bennett, Joe DiPietro's *F***ing Men* and Craig Higginson's *Dream of the Dog* with Dame Janet Suzman.

Rediscoveries of neglected work have included the first London revivals of Rolf Hochhuth's *Soldiers* and *The Representative*; both parts of Keith Dewhurst's *Lark Rise to Candleford*; *The Women's War*, an evening of original suffragette plays; *Etta Jenks* with Clarke Peters and Daniela Nardini; Noël Coward's first play, *The Rat Trap*; Charles Wood's *Jingo* with Susannah Harker; Emlyn Williams' *Accolade* with Aden Gillett and Graham Seed; Lennox Robinson's *Drama at Inish* with Celia Imrie and Paul O'Grady; and J.B. Priestley's *Cornelius* with Alan Cox.

Music Theatre has included the new (premieres from Grant Olding, Charles Miller, Michael John LaChuisa, Adam Guettel, Andrew Lippa and Adam Gwon's *Ordinary Days* which transferred to the West End) and the old (the UK premiere of Rodgers and Hammerstein's *State Fair* which also transferred to the West End, and the acclaimed Celebrating British Music Theatre series, reviving forgotten British musicals including *Gay's The Word* by Ivor Novello with Sophie-Louise Dann, Helena Blackman and Elizabeth Seal.

The Finborough Theatre won The Stage Fringe Theatre of the Year Award in 2011, won *London Theatre Reviews'* Empty Space Peter Brook Award in 2010 and 2012, the Empty Space Peter Brook Award's Dan Crawford Pub Theatre Award in 2005 and 2008, the Empty Space Peter Brook Mark Marvin Award in 2004, four awards in the inaugural 2011 OffWestEnd Awards and swept the board with eight awards at the 2012 OffWestEnd Awards including Best Artistic Director and Best Director for the second year running. *Accolade* was named Best Fringe Show of 2011 by *Time Out*. It is the only unsubsidised theatre to be awarded the Pearson Playwriting Award bursary for writers Chris Lee in 2000, Laura Wade in 2005, James Graham in 2006, Al Smith in 2007, Anders Lustgarten in 2009, Simon Vinnicombe in 2010 and Dawn King in 2011. Three bursary holders (Laura Wade, James Graham and Anders Lustgarten) have also won the Catherine Johnson Award for Pearson Best Play.

www.finboroughtheatre.co.uk

The Associate Director position is supported by The National Theatre Studio's Bursary for Emerging Directors, a partnership between the National Theatre Studio and the Finborough Theatre.

The Finborough Theatre has the support of the Pearson Playwrights' Scheme. Sponsored by Pearson PLC.

The Cameron Mackintosh Resident Composer Scheme is facilitated by Mercury Musical Developments and Musical Theatre Network UK

The Finborough Theatre is a member of the Independent Theatre Council, Musical Theatre Network UK and The Earl's Court Society www.earlscourtsociety.org.uk

Mailing
Email admin@finboroughtheatre.co.uk or give your details to our Box Office staff to join our free email list. If you would like to be sent a free season leaflet every three months, just include your postal address and postcode.

Follow Us Online

www.facebook.com/FinboroughTheatre
www.twitter.com/finborough

Feedback
We welcome your comments, complaints and suggestions. Write to Finborough Theatre, 118 Finborough Road, London SW10 9ED or email us at admin@finboroughtheatre.co.uk

Finborough Theatre T Shirts are now on sale from the Box Office, available in Small, Medium and Large: £7.00.

Friends

The Finborough Theatre is a registered charity. We receive no public funding, and rely solely on the support of our audiences. Please do consider supporting us by becoming a member of our Friends of the Finborough Theatre scheme. There are four categories of Friends, each offering a wide range of benefits.

Brandon Thomas Friends – Bruce Cleave. Matthew Littleford. Sean W. Swalwell. Michael Rangos. David Day.

Richard Tauber Friends – Neil Dalrymple. Richard Jackson. M. Kramer. Harry MacAuslan. Brian Smith. Mike Lewendon.

William Terriss Friends – Leo and Janet Liebster. Peter Lobl. Bhags Sharma. Thurloe and Lyndhurst LLP. Jon Sedmak. Jan Topham.

Smoking is not permitted in the auditorium and the use of cameras and recording equipment is strictly prohibited.

To Kasia 16/8/16

from Sexy Morcef

Don't Go!

Tom Morton-Smith

EVERYDAY MAPS
FOR EVERYDAY USE

Kash, Kash, Kash.....

I have blocked out this day.

You are one of the reasons

I came to work in BnP.

My favourite memory of working

here is that I can call you

my little sister and a best friend.

You will go on to great

things and you are one of my favourite

people in LONDON. Also, I've never had

a "girl" best friend.

OBERON BOOKS
LONDON
WWW.OBERONBOOKS.COM

Already missing you

I love you very much and I cannot wait to see you grow into a successful and gorgeous girl

First published in 2012 by Oberon Books Ltd
521 Caledonian Road, London N7 9RH
Tel: 020 7607 3637 / Fax: 020 7607 3629
e-mail: info@oberonbooks.com
www.oberonbooks.com

A catalogue record for this book is available from the British
Library.

PB ISBN: 978-1-84943-441-6
E ISBN: 978-1-84943-804-9

Cover image © Enrico G. Agostoni

Printed, bound and converted
by CPI Group (UK) Ltd, Croydon, CR0 4YY.

Visit www.oberonbooks.com to read more about all our books
and to buy them. You will also find features, author interviews and
news of any author events, and you can sign up for e-newsletters
so that you're always first to hear about our new releases.

With thanks to Roxana Silbert, Pippa Hill and Derek Bond

Characters

CORINNE RADD

MAGGIE RADD

BEHROOZ AL-MERREIKH

KEVIN 'KIPH' CROAKER

JOHN JONES

RICHARD BLEAKMAN

The play takes place in and around Woking.

KIPH's bedroom.

KIPH is sat in the dark with his laptop, the light from the screen reflecting onto his face.

He is surfing the internet looking at pornographic images.

KIPH is disgusted and closes the laptop.

Steeling himself, he opens the computer once more and continues to look at the images.

2.

The sandpit on Horsell Common – nighttime.

MAGGIE is dancing in the darkness to the music on her phone. It is loud enough that we can make out the tinny beats leaking from the headphones. She isn't wearing any shoes.

BEHROOZ enters carrying his telescope, tripod and other paraphernalia; sketchbooks and such.

MAGGIE: *(Unaware of BEHROOZ.)*

BEHROOZ: *(Watches MAGGIE with curiosity.)*

MAGGIE: *(Catches sight of BEHROOZ and lets out a little yelp of surprise.)*

BEHROOZ: *(A little shocked, his grip lessens and he nearly drops everything.)* Sorry, sorry.

MAGGIE: What the fuck?

BEHROOZ: I didn't mean to … you know … you seemed … in your own little world.

MAGGIE: *(Pulling out her earphones.)* What?

BEHROOZ: You were … own little world.

MAGGIE: Creeping up … slinky bastard.

BEHROOZ: I said I was sorry.

MAGGIE: I couldn't hear you, could I?

BEHROOZ: Alright – sorry. I'll just be … you going to be here long?

MAGGIE: Might be. What's that?

BEHROOZ: Telescope – astronomy.

MAGGIE: I'm a Gemini.

BEHROOZ: Congratulations.

MAGGIE: This is my spot.

BEHROOZ: I don't see your name on it.

MAGGIE: That's because it's dark.

BEHROOZ: I'll set up somewhere else. *(Goes to leave, turns back.)* You have to dance here?

MAGGIE: Yes.

BEHROOZ: Only …

MAGGIE: We can share, can't we?

BEHROOZ: I suppose. You going to be dancing?

MAGGIE: I expect so.

BEHROOZ: Throwing some crazy shapes?

MAGGIE: May do.

BEHROOZ: Shaking your booty?

MAGGIE: Perhaps.

BEHROOZ: Well … if you do … this stuff's expensive so … could you … mind where you shake it?

MAGGIE: Will do.

BEHROOZ: Thanks. *(Starts setting up the telescope.)*

MAGGIE: *(Dancing to her music again.)*

BEHROOZ: Aren't you cold?

MAGGIE: *(Can't hear.)*

BEHROOZ: Aren't you cold?

MAGGIE: *(Own little world.)*

BEHROOZ: *(Returns to the telescope.)*

MAGGIE: *(Loud.)* What are you looking at?

BEHROOZ: You're shouting.

MAGGIE: What?

BEHROOZ: You're shouting!

MAGGIE: *(Removes earphones.)* What are you looking at? Stars?

BEHROOZ: Planets.

MAGGIE: Planets?

BEHROOZ: Mars is in opposition … just turned … travelling from West to East rather than … it's the closest she ever gets to Earth … so she's easier to … er … you know … see.

MAGGIE: Mars is a man.

BEHROOZ: What?

MAGGIE: 'Men are from Mars …' The God of War …

BEHROOZ: Yes.

MAGGIE: You said: 'she'.

BEHROOZ: Right. Yes. I suppose I … planets seem kind of … female … innately. Something about their …

MAGGIE: Curves?

BEHROOZ: Possibly. And technically … though later he was thought of as a god of war … he had been originally conceived as … worshipped as … a god of growth and fertility. Much more … I suppose … feminine qualities.

MAGGIE: You're funny.

BEHROOZ: What?

MAGGIE: You're funny. And kind of cute. *(Offers hand.)* Maggie.

BEHROOZ: *(Shakes her hand.)* Behrooz.

MAGGIE: It's a pleasure to meet you.

Silence.

BEHROOZ: *(Fussing over his equipment.)* Do you often dance out here in the middle of the night?

MAGGIE: Yep.

BEHROOZ: Doesn't your mother worry about you?

MAGGIE: Yep.

BEHROOZ: *(Looking through the telescope's eyepiece.)* You'll get pine needles under your skin.

MAGGIE: *(Slips one of the earphones in BEHROOZ's ear and the other in hers.)*

BEHROOZ: What's this? David Bowie?

MAGGIE: Yep. *(Going through his sketchbooks.)* Maps.

BEHROOZ: Yes.

MAGGIE: Red maps.

BEHROOZ: The surface of … here, look.

MAGGIE: *(Puts her eye to the eyepiece.)*

BEHROOZ: Can you see it?

MAGGIE: Mars.

BEHROOZ: Yes. Are you impressed?

MAGGIE: Are you trying to impress me?

BEHROOZ: By the planet.

MAGGIE: This is what you do? Draw maps of Mars?

BEHROOZ: Of the Martian surface.

MAGGIE: That's a nice bit of kit.

BEHROOZ: Thank you.

MAGGIE: You've got a tripod.

BEHROOZ: Er … yeah.

MAGGIE: A tripod on Horsell Common. 'The War of the Worlds'.

BEHROOZ: Oh yes. I see. Funny.

MAGGIE: Not so funny.

BEHROOZ: Funny-curious … not funny-ha-ha.

MAGGIE: You ever read it?

BEHROOZ: No.

MAGGIE: You live in Woking and you've never read 'The War of the Worlds'?

BEHROOZ: No.

MAGGIE: You're not looking for alien cylinders then? Not looking for signs of intelligent life?

BEHROOZ: No.

MAGGIE: You're just drawing a map.

BEHROOZ: Yes.

MAGGIE: Someone must've done that already – you can't be the first.

BEHROOZ: Yeah … er … no … several.

MAGGIE: Then why bother?

BEHROOZ: Just because something's been done, doesn't mean it's not worth doing again.

MAGGIE: NASA could just point the Hubble at it – snap! – more accurate.

BEHROOZ: This isn't about accuracy. It was all photographed in the Seventies. People still climb Everest. I'm climbing Olympus Mons.

MAGGIE: Olympus …?

BEHROOZ: … Mons. The solar system's largest volcano. Three and a half million cubic kilometres of rock – four times the volume of all the Alps put together. *(Pause.)* You think I'm daft, don't you? Think I'm soft in the head.

MAGGIE: No. It's just all a bit … you know … *alien* to me. You're a bit alien. *(Beat.)* Give me your hand.

BEHROOZ: *(Does.)*

MAGGIE: *(Pulls him down to feel the ground.)* Can you feel that?

BEHROOZ: What?

MAGGIE: It's warm.

BEHROOZ: Yeah?

MAGGIE: It's *warm.*

BEHROOZ: Am I missing something here?

MAGGIE: Why would it be warm?

BEHROOZ: I don't know … a pipe? A phoneline?

MAGGIE: Out on the common?

BEHROOZ: Any number of reasons.

MAGGIE: There's something under here. Something giving off immense heat. Something pulsing and vibrating. Something buried. You're very beautiful. And I want you to fuck me. Here. On this warm patch of earth. I want you to fuck me.

BEHROOZ: How old are you?

MAGGIE: Sixteen. It won't be my first time if that's what you're worried about.

BEHROOZ: I don't know if that makes it any better.

MAGGIE: You're very beautiful.

BEHROOZ: *(Considers.)* Here?

MAGGIE: Here. *(Starts kissing him.)*

BEHROOZ: It's because I'm Middle Eastern, isn't it?

MAGGIE: What?

BEHROOZ: I'm exotic … I'm dusky … I'm alien.

MAGGIE: Fuck me now or I'm going home.

BEHROOZ: *(Kisses her with a passion, pulling at her clothes.)* I've been watching you … night after night … dancing in your own little world … from up there on the ridge … by the bench.

MAGGIE: I know.

They fuck.

3.

A comic book and cult entertainment store.

RICHARD is sat at a table with a pile of DVD boxsets next to him, ready for a signing.

KIPH, wearing a charity worker's tabard, stands before RICHARD.

KIPH: Am I late?

RICHARD: No.

KIPH: Am I early?

RICHARD: No.

KIPH: Where is everybody?

RICHARD: You want me to sign one? Who shall I make it out to?

KIPH: I've got them all on VHS … all four series … waited a long time for a DVD release.

RICHARD: Low demand, I suppose. Who shall I …?

KIPH: Kiph.

RICHARD: Is that your real name?

KIPH: It's what everyone calls me. K … I … P … H.

RICHARD: *(Signs one of the boxsets.)*

KIPH: I was going to come dressed as Tars Tarkas – chieftan, Jeddak and King of the Green Martians – I've got the costume and everything – but I'm on my lunchbreak. Can I get two?

RICHARD: Sure.

KIPH: Please.

RICHARD: Who shall I make this one out to?

KIPH: 'Kiph' again, if you don't mind … only … could you sign as John Carter?

RICHARD: What …?

KIPH: 'To Kiph, who has saved my life a thousand times, the finest shot with a radium pistol, eternal gratitude, John Carter' ... something like that.

RICHARD: You know that ...

KIPH: Yeah, I know.

RICHARD: ... I'm just an actor.

KIPH: Yeah. I know.

RICHARD: John Carter is a character. I'm Richard Bleakman. You already have one signed by me. I've never been to Mars.

KIPH: I'd like one from the actor who played John Carter and one from John Carter himself. That's not too weird, is it?

RICHARD: *(Signs.)* You'd think ... with all the conventions I've done ... I'd be used to this kind of ... but you people always ... I don't know ...

KIPH: Do you still ... on the convention circuit?

RICHARD: Not so much ... not for ... not for a long while.

KIPH: Could I ... can I have a picture? *(Pulls out a mobile phone.)*

RICHARD: *(Sighs and stands.)*

KIPH: *(Stands next to RICHARD, holds the phone at arm's length and takes a photo.)* Will you speak to my friend?

RICHARD: I don't think –

KIPH: Please?

RICHARD: *(Acquiesces.)*

KIPH: *(Puts phone to his ear.)* It's ringing.

RICHARD: Sure.

KIPH: *(On phone.)* Maggie? Hey. You'll never guess who I've got here with me. *(Hands RICHARD the phone.)*

RICHARD: Hello? This is Richard Bleakman. Richard Bleakman. I played John Carter in the TV show 'John Carter of Mars'.

KIPH: Do the voice.

RICHARD: What?

KIPH: The voice.

RICHARD: *(In a syrupy Virginian accent.)* Well, hello there, young miss. Hope y'all are well. The people of the Kingdom of Helium send their kindest regards. I'll make sure to pass that on, young miss. *(Hangs up.)* She called you a dick.

KIPH: You weren't in the film.

RICHARD: No.

KIPH: Not even a cameo.

RICHARD: No.

KIPH: You could've been a Thark ... done the whole motion capture ... CGI ...

RICHARD: No.

KIPH: Would you have done it, if they'd asked?

RICHARD: No.

KIPH: Did they ask?

RICHARD: No.

KIPH: Did you find Sarkoja attractive?

RICHARD: What?

KIPH: Did you ever – ?

RICHARD: She was a twelve-foot tall, six-limbed, green Martian with upward pointing tusks. The stuntman who played her was called Jeremy. I did not find her attractive.

KIPH: But the idea of her ...?

RICHARD: No.

KIPH: Have you ever watched ... have you ever seen ... manga ... anime ...

RICHARD: Is that ... is that Japanese ...?

KIPH: Yeah.

RICHARD: No.

KIPH: It's pretty interesting … pretty graphic. Fascinating … as a subject … because it's illegal in Japan to show penetrative sex … to draw … to animate … so the animators get round by using aliens … tentacles … to penetrate instead of … instead of the usual … to get round the censors. It's fascinating because …

RICHARD: Right. Will that be all?

KIPH: I think you're amazing. I really do. You watch it again and yes, the effects have dated and yes, the monsters look shoddy and yes, the story's almost exactly the same every week. But the wobbly sets and the badly handled bluescreen … that's just where … it's where …

RICHARD: Sure.

KIPH: In amongst the big hair and the synthesisers … there was you … being truthful. I believed in your peril. You were subtle and dignified – exactly how I'd imagine a Confederate soldier on the surface of Mars to be. And because *that* worked … because the core of it was believable … everything else seemed so too. I was with you on Mars. Fighting the monsters and saving the world. Not our world, obviously. Rescuing the princess in the skimpy outfit … reversing the polarity … phase-inducing the tachyon pulse. And I was a part of it … felt I was a part of it. I just wanted to say thank you.

RICHARD: Kiph … it was just a TV show …

KIPH: I like hiding behind the sofa.

RICHARD: I'm done here. So if you don't mind …

KIPH: Yeah … I've got to get back to …

RICHARD: Thanks for coming out. Goodbye, Kiph. I would've liked to have seen your costume.

KIPH: *(Salutes.)* Fare you well, John Carter of Mars.

RICHARD: *(Returns the salute.)*

4.

CORINNE's front room.

JOHN and CORINNE.

JOHN is inspecting a photograph. A dumpy level and a metre wheel – the tools of the cartographer – are to one side.

CORINNE: I can't thank you enough.

JOHN: No problem.

CORINNE: So lucky you were passing … and weren't … you know … psychotic.

JOHN: It was no bother. Really. You should keep a spare key under a flowerpot … or something.

CORINNE: I wouldn't like to do that. First place people would look … under the flowerpots.

JOHN: I suppose so. *(Hands CORINNE the photo.)* She seems very nice.

CORINNE: *(Puts the photo in its rightful place inside her purse.)* When she's not plastered in make-up.

JOHN: Well …

CORINNE: She's an absolute angel. She's more like a best friend than a daughter.

JOHN: That's nice. *(Pulls a photo out of his wallet.)* This is the most recent … see, that's the head … and the fingers …

CORINNE: Oh, sweet. Boy or girl?

JOHN: We don't know – don't want to know.

CORINNE: What would you prefer?

JOHN: As long as they're healthy.

CORINNE: And even then.

JOHN: Well, yes.

CORINNE: How far gone?

JOHN: Six months.

CORINNE: Bless. She can't be getting a wink of sleep.

JOHN: No?

CORINNE: I never did.

JOHN: I think she's … I mean … she hasn't complained … not to me, but … well …

CORINNE: She feels she's doing all the work and you don't feel important.

JOHN: It's not … we haven't … talking has become … and separate rooms.

CORINNE: Are you having sex?

JOHN: Um …

CORINNE: It's good … it's healthy to have plenty of …

JOHN: I can't …

CORINNE: Six months?

JOHN: I can't touch her … not like that.

CORINNE: Why ever not?

JOHN: There's someone else there. It'd be … it'd be … it wouldn't be right.

CORINNE: You need to get over that.

JOHN: What if I felt it kick … while inside … what if I'm on top of her and I felt it kick? Sorry. Ridiculous. I'm being …

CORINNE: You're fine.

JOHN: I've known you … what … matter of minutes … half an hour … and frickin' marriage counsellor.

CORINNE: Sometimes you can tell strangers things you couldn't tell the love of your life.

JOHN: Must've been worse after she was born.

CORINNE: What was?

JOHN: Sleeping.

CORINNE: No. Not at all. She never screamed, even when … the cord had wrapped around her neck and … you don't want to be hearing this.

JOHN: I do.

CORINNE: Horror stories … what can go wrong … it'll just
play on your mind.

JOHN: She's perfectly fine now?

CORINNE: Yes.

JOHN: Well then.

CORINNE: She was grey when she came out … spindly limbs
… she was ugly … covered in mess and no colour in her
skin. Those nights … not sleeping … alone with your
thoughts and this creature inside of you. Lying awake
and your terrors carry you away. 'I hope they're healthy.'
'What if they're not?' 'What if they're not properly
developed?' 'What if they're brain-damaged?' 'What if it's
got no legs?' 'What if it's got no eyes?' 'What if it's got an
extra limb?' You see those documentaries about children
born with their twin inside their stomach. A monster
in your gut. Something squirming. I've since … on the
internet … researched … a fear of monsters in your belly.
It's apparently quite common. I should've … I should've
spoken to someone about it, instead of keeping it to myself
… made it worse. *(Beat.)* I'm sorry.

JOHN: Don't be.

CORINNE: I'm sorry … I'm not usually one for talking … not
for … not like this …

JOHN: I'm the same.

CORINNE: So you're a cartographer. The cartography business
… what's that like?

JOHN: It's all computers … not as … not very … not creative.

CORINNE: 'Here be dragons'.

JOHN: No.

Silence.

CORINNE: Thank you … for scaling drainpipes and unlocking
doors. I would've been out in the cold. Where are you

staying? While in Woking – you said … only here a couple of days and …

JOHN: Travelodge.

CORINNE: Right. What are your plans? What are your …? Are you … are you just heading back there now … to the … to the …

JOHN: Yes.

CORINNE: Well … perhaps I could … Travelodge.

JOHN: I'm married.

CORINNE: Right. Right.

JOHN: We may have our problems –

CORINNE: Fine.

JOHN: I love my wife.

CORINNE: I wouldn't ask you to stop.

JOHN: I'll be heading off …

CORINNE: Thank you. Again. I could've been there all night.

JOHN: Not a problem. You should be more …

CORINNE: I will. It won't happen again. I should chain my keys to my wrist. Thank you also … for the talking.

JOHN: Yeah. It was … yeah. Goodbye.

CORINNE: If you want … let me … *(A business card.)* If you want to talk … or if you change your …

JOHN: I'll … er … thanks.

CORINNE: If you change your mind.

JOHN: Bye then.

CORINNE: Bye.

JOHN: It's nothing personal.

CORINNE: You don't have to …

JOHN: You're a very attractive lady …

CORINNE: I'm too old for you.

JOHN: I'm married. Goodbye. *(Gathers his equipment and leaves.)*

CORINNE: *(Alone.)*

5.

MAGGIE's bedroom.

MAGGIE cross-legged. KIPH in the doorway holding a DVD.

KIPH: I looked at it.

MAGGIE: I didn't ask you to.

KIPH: I googled it.

MAGGIE: I didn't want you to.

KIPH: It's ridiculous … I mean … I didn't think you were … I thought you might've been pulling my leg. But no … you type it in and … there are websites … no end of images … cartoons. There are forums and discussion boards. A subculture. All of these people … across the world … and they're drawing pictures and sharing pictures … manga … anime. Japanese schoolgirls and tentacle monsters. Is it more normal in Japan … more accepted?

MAGGIE: I better move to Tokyo then.

KIPH: No … don't do that … I just … I want you to feel normal.

MAGGIE: I feel normal enough.

KIPH: This … I bought this … off the internet … from a mainstream entertainment outlet. Highly recommended … five stars on Amazon. If you want tentacle stuff then this … this is … 'Legend of the Overfiend'.

MAGGIE: Did you watch it?

KIPH: Not all the way through. Is this it … I mean … is this what you like?

MAGGIE: It's … you know … it's cool … whatever.

KIPH: I didn't even know this sort of thing existed. It's pretty … er … it's pretty …

MAGGIE: Pretty …?

KIPH: … grim … not grim … weird … no … I …

MAGGIE: Kiph, just … don't …

KIPH: I got about … I don't know … a third of the way
 through? I thought we could watch the rest of it together.

MAGGIE: I don't want …

KIPH: We could get some popcorn … turn the lights down …
 maybe cuddle up –

MAGGIE: No.

KIPH: If this is the sort of thing that you're into … then that's
 fine … I can get onboard with that. It's given me an insight
 …

MAGGIE: Forget it.

KIPH: … insight into how you … how you tick.

MAGGIE: Wipe it from your mind.

KIPH: Consider me mind-wiped.

MAGGIE: I wish you hadn't watched it.

KIPH: I'm not shocked. I am unflappable.

MAGGIE: Shut up, Kiph. If you want to stay then just … shut
 up.

KIPH: It doesn't change the fact that I love you.

MAGGIE: Shut the fuck up.

 Silence.

KIPH: I'm going to … er …

MAGGIE: What?

KIPH: Go. I'm going to go.

MAGGIE: Okay.

KIPH: It's not because of … when I say that I love you … it's
 not because of …

MAGGIE: What?

KIPH: I want you to know that.

MAGGIE: It's not because of … what?

KIPH: The gay thing.

MAGGIE: What gay thing?

KIPH: Don't … don't pretend you don't …

MAGGIE: Sorry.

KIPH: I'm not saying it to prove … not saying it to dispel …

MAGGIE: I didn't think you were.

KIPH: I wouldn't have a problem if I was gay … but I'm not. I like girls … I like girls and tits.

MAGGIE: Sure.

KIPH: My parents would be supportive and understanding.

MAGGIE: I know they would.

KIPH: I wouldn't use those words cheaply.

MAGGIE: I know.

KIPH: I like big tits.

MAGGIE: Kiph …

KIPH: I'm okay with it … this stuff. Most guys wouldn't be. Most guys would run screaming. Not me. Japanese schoolgirls being pinned down by alien tentacles … little pink panties and hair in bunches. *(Beat.)* An animated movie is not an easy – or cheap – thing to create. There are twenty-four frames per second … and each cell is hand drawn. Colourists … inkers … editors … directors … actors … hundreds of people involved … and there are hundreds of titles. There must be an audience … a substantial audience … to warrant the investment, the funding … so it can't be that uncommon. Tentacle monsters. If you rationalise how many people –

MAGGIE: Stop.

KIPH: We can watch it together … whatever floats your boat … because I think you're beautiful.

MAGGIE: Stop trying to understand.

Silence.

KIPH: What I don't understand is that … I mean, your knickers are up and down for … why not for me?

MAGGIE: You'd want more from me than just sex.

KIPH: I could cope with just sex. *(Beat.)* Neither of us are exactly the social norm … so doesn't it make sense that we …?

MAGGIE: You're my best friend … you mean too much. *(Beat.)* Mum thinks you're taking me to the cinema tonight.

KIPH: Okay.

MAGGIE: You know … if she asks.

KIPH: Sure. Where are you going?

MAGGIE: Just out.

KIPH: Where out?

MAGGIE: Out.

KIPH: I want to come.

MAGGIE: I don't want you there.

KIPH: You said I was your –

MAGGIE: It's not a place for friends.

KIPH: What's it a place for?

MAGGIE: Kiph …

KIPH: Friends tell each other everything.

MAGGIE: Not everything.

KIPH: Is it something freaky? I promise I won't get freaked. I want to know … I want to share … because that's what love is … loving despite … loving in spite of. Nothing you can say will change how I feel.

MAGGIE: You think so?

KIPH: I want to understand.

MAGGIE: There's a patch of ground on the common – in the basin – it's *warm*. It radiates heat – like there's something under there. And it's right where the first cylinder landed … where they first used the heat ray … where first contact was made. A buried Martian craft. And it's been waiting … for a hundred years … covered in Victorian sand and forgotten. But it's alive and … and warm … and I can feel it through my toes. And I dance on that spot … on that warm patch … and there are men. Men on the common. And I want them to fuck me. I want them to fill me. And I squirm and I wriggle and I protest, just a little to make them pin me down … pin my hands into the ground. And they grind … and they groan … and they sweat. And beneath me the warm patch is getting hotter … burning now … turning the ground around me to glass … my wrists … my ankles … encased in glass. And they're grinning … their faces split from side to side … pointed teeth and saliva. Even if I wanted to … even if I wanted to stop … I couldn't. And then something climbs … something … inside … it climbs inside them … and I look up and their … their eyes have turned black and their skin to leathery brown and they kiss me with their lipless beaks. And their arms are now tentacles and they're all over my body and pushing through my skin … thousands of branching tentacles under my skin. And they're sucking out my blood … they're in my circulatory system and they're sucking out my blood. They don't have hearts. None of them have hearts and they need my blood to pump through their veins … and then … they're spent and I'm drained. They're human again and buttoning up their trousers. And they walk off … back toward Woking. The heat has gone from the ground … but a little bit … a little flicker … has transferred inside of me. *(Pause.)* Are you going to freak out?

KIPH: No … I … I'm not … I've just got to … go. I'll … maybe … speak soon. *(Exits.)*

MAGGIE: *(Alone.)*

6.

CORINNE's art gallery.

BEHROOZ is hanging canvases on the wall. The canvases are beautifully rendered maps of the Martian surface.

CORINNE is setting up a tripod and camera in front of one of the paintings.

BEHROOZ: That's not … that's probably not the best one … for the poster. It should be something iconic … one of the valleys or volcanoes.

CORINNE: I know what I'm doing. I was thinking we should have someone reading passages from the book … someone dressed as HG Wells …

BEHROOZ: Really?

CORINNE: Or as a Martian. We could hand out some of those deely-boppers … you get the ones with flashing LED lights …

BEHROOZ: I'd really rather we didn't.

CORINNE: Where's your sense of fun?

BEHROOZ: There's fun and there's tacky.

CORINNE: You're being rather obstructionist.

BEHROOZ: I'm sorry.

CORINNE: You have to capitalise on … Woking and Mars … it's a hook. There's a huge great statue of a Martian tripod on the high street … you have to know your market, and Woking is little green men and monsters.

BEHROOZ: Sure … no … I get it, but that's not … well, it's not *real.*

CORINNE: Barsoom, these are maps of an alien planet.

BEHROOZ: What's your point?

CORINNE: Well, hardly … it's hardly *realism.*

BEHROOZ: It's a place … an actual place … with actual rocks and actual sky. A solid place. It's an alien landscape,

sure … but not some fantasy … not made up … not some grotesque Wookiee or Klingon or … or … I don't know. *(Beat.)* I've been dreaming of an exhibition … this exhibition … I've given up a career … I have taken a chance …

CORINNE: The dream is fine … the romance – life as an artist – is fine … but it's human nature to start with romance and build to a reality.

BEHROOZ: Okay.

CORINNE: Okay?

BEHROOZ: Okay.

CORINNE: *(Adjustments to the camera.)* Damn … there's no … the batteries are dead. Look in my handbag, down there somewhere.

BEHROOZ: *(Finds handbag.)*

CORINNE: Got it?

BEHROOZ: Yep.

CORINNE: There's some money in the purse.

BEHROOZ: *(Opens her purse, something catches his eye, the photograph.)*

CORINNE: Find it?

BEHROOZ: *(Distracted.)*

CORINNE: Barsoom, did you find it?

BEHROOZ: What? Yeah, yeah. *(Puts the photo back, takes some money.)*

CORINNE: Would you mind popping out …?

BEHROOZ: Batteries. Sure. *(Pause.)* That's not my name, you know.

CORINNE: What's that?

BEHROOZ: My name. It's Behrooz.

CORINNE: What have I been calling you?

BEHROOZ: Barsoom … or something … anyway it's Behrooz.

CORINNE: Oh god, I am so sorry. I'm terrible with Indian names.

BEHROOZ: I'm not Indian.

CORINNE: Right. Sorry.

BEHROOZ: Just don't want you putting it wrong on the posters.

CORINNE: Will you write it out for me?

BEHROOZ: Sure. Do you have a pen?

CORINNE: No.

BEHROOZ: Maybe later. I'll go get your …

CORINNE: They are beautiful. Really. Strange to see a map of somewhere no one's ever been.

BEHROOZ: Once we're there – building cities, melting the permafrost to fill the oceans, turning red into blue – we'll no longer have to imagine. And I think that's sad.

CORINNE: Once we're there?

BEHROOZ: Yeah. I'll be there for the opening of your second gallery – the first gallery in the Martian capital.

CORINNE: Yes! And I'll be exhibiting more of your work … only this time it'll be the surface of Earth. Huge maps of the surface of Earth!

BEHROOZ: What would be the point of that?

7.

The sandpit on Horsell Common – nighttime.

MAGGIE is dancing in the darkness to the music on her phone. It is loud enough that we can just make out the tinny beats. She isn't wearing any shoes.

No one comes.

8.

CORINNE's front room.

A spider-plant hangs from the ceiling. A small suitcase to one side.

RICHARD, nervous.

CORINNE with two mugs of tea.

RICHARD: You live alone?

CORINNE: No. I live with my daughter.

RICHARD: And she's …? Sorry. You probably don't want me talking about your daughter.

CORINNE: It's alright.

RICHARD: Still … better to remain … on a more formal footing.

CORINNE: If you like.

RICHARD: No need to share any personal details … keep it clinical.

CORINNE: Clinical?

RICHARD: That's not the right … not in a … I don't mean … clinical is the wrong word.

CORINNE: Businesslike?

RICHARD: Well … that implies … and you're not expecting me to … and you're not … a 'lady of the night'.

CORINNE: No.

RICHARD: No.

CORINNE: And it's the middle of the day.

RICHARD: I didn't mean to insult …

CORINNE: Have you done this before?

RICHARD: Yes. Of course.

CORINNE: The internet?

RICHARD: Oh … I thought you meant … in general. The internet? No. Problem?

CORINNE: No.

RICHARD: Is it obvious?

CORINNE: You're a little tense, that's all.

RICHARD: It's been a while … under any circumstances.

CORINNE: Have we met before?

RICHARD: I have one of those faces.

CORINNE: What do you do?

RICHARD: What do I …?

CORINNE: Your job.

RICHARD: I'm a … I … do we have to …?

CORINNE: Too personal? Fine.

RICHARD: Better not to know too much.

CORINNE: You know where I live.

RICHARD: Yes … but …

CORINNE: Fine.

RICHARD: Not married?

CORINNE: Is that not personal?

RICHARD: Sorry.

CORINNE: Divorced. You?

RICHARD: Widowed.

CORINNE: What do you want to get out of this afternoon?

RICHARD: Well … um … sex.

CORINNE: I'm not looking for a relationship, and I simply cannot stomach the idea of meeting men in bars … in nightclubs … no. Like-minded individuals … no baggage … no repercussions. Yes?

RICHARD: Yes.

CORINNE: Good. So … what are you into?

RICHARD: You mean … sex?

CORINNE: Yes, I mean sex.

RICHARD: Yeah … well … the usual.

CORINNE: What's your name?

RICHARD: My … I … er …

CORINNE: I can't refer to you as ThirdLeg56 all day.

RICHARD: Why not?

CORINNE: Fine. If that's what you want. But, please, my name's –

RICHARD: CumSlut69.

CORINNE: Fine.

RICHARD: It just … keeps a distinction … in my head.

CORINNE: Fine.

RICHARD: So …

CORINNE: So?

RICHARD: How do we … should I …? *(Starts unbuttoning his shirt.)*

CORINNE: I'll do that. *(She undresses him down to his pants, starts removing her clothes.)*

RICHARD: I'm sorry … saggy … hairy …

CORINNE: Don't …

RICHARD: Sorry.

CORINNE: Don't apologise. *(Opens the suitcase.)*

The suitcase is full of sex toys.

RICHARD: What is … what are … I'm not into …

CORINNE: What?

RICHARD: I just want …

CORINNE: Anything take your fancy?

RICHARD: I'm not gay.

CORINNE: I'm sorry?

RICHARD: I don't want anything … those are designed to … be strapped … inserted … I'm not into …

CORINNE: I'm not going to do anything you're not comfortable with.

RICHARD: Don't put anything … just … I'm straight.

CORINNE: Am I a man?

RICHARD: No.

CORINNE: No.

RICHARD: What should ...? What would you ...?

CORINNE: I like to be in control.

RICHARD: Okay ...

CORINNE: I've been thinking about erotic-asphyxiation of late ... reduces the bloodflow to the brain ... increases sensitivity of the vaginal wall ... but maybe ... perhaps that's a little advanced.

RICHARD: I just want ...

CORINNE: What do you want?

RICHARD: Just sex.

CORINNE: In a bed?

RICHARD: Yes! In a bed. You underneath, me on top.

CORINNE: Vanilla.

RICHARD: Normal.

CORINNE: You're saying that I'm not normal?

RICHARD: No, I –

CORINNE: This is what people do – just enjoy each other ... the physicality.

RICHARD: It's all a bit sordid.

CORINNE: Then why are you here?

RICHARD: I ...

CORINNE: This is just bodies – bodies enjoying each other – and being silly and playing games. It's meant to be fun. You don't seem to be having fun.

RICHARD: I just want to have sex ... with a woman ... just plain straight sex.

CORINNE: Then get yourself a girlfriend. Get yourself a wife. Pay an escort to lie on her back for you. Don't surf the net looking for …

RICHARD: My tea's gone cold.

CORINNE: Let me try something. Nothing too awful. Let me try? *(Takes handcuffs from the suitcase, handcuffs RICHARD, takes down the spider-plant and hangs him from the hook.)*

RICHARD: *(Feet barely touching the floor.)* I …

CORINNE: Shh. *(Takes a black leather ball-gag from the suitcase and places it in his mouth, she does the strap up behind his head, she stands looking at him.)*

RICHARD: *(Tries to smile.)*

CORINNE: You've been a very bad boy … thinking dirty, dirty thoughts. You need to be punished. You need –

A mobile phone rings. They look at each other.

CORINNE: *(Finds her mobile phone, apologetic look at RICHARD.)* I'm sorry … business. I have to take this. *(Exiting.)* Barsoom, hi. Yes, I did get that email … *(Gone.)*

RICHARD: *(Swaying from side to side, hangs his head.)*

There is the sound of a key in a lock.

RICHARD: *(Petrified.)*

The door opens and MAGGIE enters.

MAGGIE: *(Tinny music coming from her headphones, she sees RICHARD and takes them from her ears.)* Hello. *(She looks around the room, hears her mother offstage, she crosses to RICHARD's trousers on the floor, rifles through them until she finds his wallet, she takes some cash.)* Thanks. *(Looks at him again.)* Don't I know you from somewhere?

RICHARD: *(Shakes head.)*

MAGGIE: *(Takes pictures of him with her mobile phone.)*

CORINNE: *(Re-enters.)* No, I think it's a great idea. It's not tacky, it's … *(Sees MAGGIE and lets out a little yelp.)*

Silence as glances are passed between the three of them. The only sound is that of BEHROOZ's voice, tiny inside the mobile phone, asking 'Hello? Hello?'

9.

BEHROOZ's flat.

JOHN is sat flicking through BEHROOZ's notebooks.

BEHROOZ stood uncomfortably to one side.

JOHN: Still fantasising about Mars, I see. They're good – well, beautiful. Not very accurate.

BEHROOZ: Accuracy isn't everything.

JOHN: No. You well? What you up to?

BEHROOZ: What?

JOHN: What are you –?

BEHROOZ: What am I up to?

JOHN: Yeah. In your life.

BEHROOZ: Fuck's sake.

JOHN: You're not …

BEHROOZ: What?

JOHN: You're out of the … cartography …

BEHROOZ: Yeah.

JOHN: Just maps of Mars. I'm … for the … AtoZ.

BEHROOZ: Congratulations.

JOHN: I'm an achiever. I have achieved. I'm starving. You got something to eat?

BEHROOZ: *(Exits.)*

JOHN: *(Takes off his coat and makes himself at home.)*

BEHROOZ: *(Returns with a tube of Pringles.)*

JOHN: Nice. I'd kill for some hummus.

BEHROOZ: *(He has no hummus.)*

JOHN: I've missed you, you know? Missed hanging out with you, talking with you. Why do people drift apart, eh? Do you keep in contact with anyone from …? No? Neither do I. I'm updating … you know … Woking. Mini roundabouts. New one-way systems. Housing developments. Have to be thorough. Have to be exact. Not like you with your Martian … never changes. Every now and again you might want to mark the landing site of whatever remote control car they've sent up. But other than that … and what's that – once every ten years? Maps should always be shifting things. Border disputes, the shedding of colonial names, all that shit. I miss you. And your cooking. *(Pause.)* Do you know how bad I feel? How sick?

BEHROOZ: I got your invite.

JOHN: You didn't RSVP.

BEHROOZ: I didn't want to come.

JOHN: No.

BEHROOZ: How is …?

JOHN: She's a lovely girl – *woman* – and we're very happy. She's six months pregnant. *(Beat.)* Don't look at me like that.

BEHROOZ: How am I supposed to look at you?

JOHN: Like a friend … an old university friend who you haven't seen in … an old flatmate … a confidante.

BEHROOZ: *(Scoffs.)*

JOHN: What? We were. We used to tell each other everything. Maybe not everything. I can get you a job. With the AtoZ. If you want. It's just everyday maps. Not as … not as … *fantastical* as …

BEHROOZ: I make enough money.

JOHN: Seriously?

BEHROOZ: I sell paintings. I've got an internet site.

JOHN: Paintings of what? Of Mars?

BEHROOZ: I ship all over the world.

JOHN: How many you sold? Come on, 'entrepreneur', how many you sold?

BEHROOZ: Two.

JOHN: 'All over the world'?

BEHROOZ: Woman in America bought one – present for her husband. I've got an exhibition coming … *(Beat.)* I don't have to defend … you can't make me feel small.

JOHN: You've the moral high-ground, yeah? *(Pause.)* An exhibition? That's good. You're living the dream. I'm proud. *(Pause.)* You got no hummus … no salsa? I'd settle for some cheese and chive … maybe some sour cream … bean dip? I've got a mate who … er … can't get his head round the concept of hummus. Chick peas to him are just … he calls them little balls of … he says it looks like recycled paper pulp … just a newspaper mashed up with some garlic, chucked in a blender and sold in little plastic –

BEHROOZ: I buried it.

JOHN: Mind you, this is the same guy who claims pâté is just cat-food repackaged for humans.

BEHROOZ: I took a sledgehammer to it. Took my Dad's blowtorch. It's in tiny pieces.

JOHN: I mean, I like pâté, but now I see pâté on the menu and I read Whiskas.

BEHROOZ: Why are you talking dips … pâté?

JOHN: I just … *(Beat.)* Bit extreme, don't you think? Obliterating it like that? Where'd you bury it?

BEHROOZ: All over the fucking place. Threw bits in the sea … in the Thames … in Lake fucking Windermere. Took me a week. Drove all over the fucking country to dispose –

JOHN: You just had to format the hard-drive.

BEHROOZ: I'm not going to have that in my house.

JOHN: Got yourself a new one?

BEHROOZ: Yeah. Mac.

JOHN: Nice.

BEHROOZ: 17-inch widescreen, 512 megabyte SDRAM, 160 gigs HDD. Wireless mouse.

JOHN: Sweet.

BEHROOZ: Yeah. *(Beat.)* Why are you here?

JOHN: Mapping Woking. AtoZ.

BEHROOZ: No. In my front room. Eating Pringles.

JOHN: To say sorry.

BEHROOZ: Well say it and fuck off.

JOHN: You were never meant ... some things should never ...

BEHROOZ: Sorry isn't ... apologising isn't strong enough? Where's your shame? Where's your self-disgust?

JOHN: It's here. It's all here. *(Pause.)* It's not like it hurt anyone.

BEHROOZ: You're just sorry you got found out. Get the fuck out of my house.

JOHN: I'm sorry. I'm *so* sorry. I love you, man. You know me better than anyone else –

BEHROOZ: I wish I didn't.

JOHN: I'm sorry but it's not like I did anything ... it was just a story ... it's not like it was images ...

BEHROOZ: On my computer.

JOHN: There was nothing wrong with your computer.

BEHROOZ: How do you know? They track those websites. The police could've stormed in, seized my hard-drive and I'd've got the blame. For your sickness! Me!

JOHN: They wouldn't've found anything. I would've deleted it.

BEHROOZ: When? After you'd finished with it? After you'd wanked yourself raw and numbed yourself to it? And then what? You'd've downloaded something else ... something worse. I can't even begin ... I can't even ...

JOHN: It was just a stupid story. A fantasy. I'm not a pervert. It seems daft to lose a friend over something that's not even real. *(Goes to exit.)*

BEHROOZ: Wait. I haven't got your phone number. *(Hands JOHN his mobile.)* Put it in.

JOHN: *(Does so, hands it back.)*

BEHROOZ: *(Looks at the screen.)* And your home number.

JOHN: What?

BEHROOZ: Your landline.

JOHN: *(Does so, hands it back.)*

BEHROOZ: *(Makes a call.)*

JOHN: What are you doing?

BEHROOZ: Calling your wife.

JOHN: *(Makes a grab for the phone.)*

BEHROOZ: *(Avoids him.)* She's not picking up. Don't you have an answer-service?

JOHN: No.

BEHROOZ: I'll call back later.

JOHN: What?

BEHROOZ: Maybe in an hour. Maybe in a week. Maybe in a month or maybe in three months. Maybe on your kid's first birthday … your wife'll get a phone call from me.

10.

CORINNE's gallery.

CORINNE is surrounded by BEHROOZ's maps.

MAGGIE stands in the doorwaqy.

CORINNE: You should be at home. I left you some soup. There's some Lucozade in the fridge. You should be curled up in bed.

MAGGIE: I'm fine.

CORINNE: If they sent you home from school …

MAGGIE: Just a headache.

CORINNE: … you should be tucked up …

MAGGIE: I'm not feverish.

CORINNE: … you should be tucked up and … cosy. You shouldn't be … you shouldn't …

MAGGIE: Mum …

CORINNE: I suppose you're wondering … you must be so confused … you must think I'm some … I don't make a habit of … I'm supposed to protect you … I'm supposed to … teach you values … family … I'm not supposed to bring it … into … our home … our doorstep … *(Pause.)* Have you seen these? They're good. They're good, aren't they. Somewhere you can escape to … somewhere … a landscape … where … you can make your own … *(Pause.)* I'm so fucking disgusting.

MAGGIE: You're not …

CORINNE: You should have a childhood … you should have a childhood … not … not have me … I don't make a habit of …

MAGGIE: Yes you do. And it's okay.

CORINNE: I do?

MAGGIE: I'll show you how to delete your computer's history file.

CORINNE: You must be so disappointed … to discover your mother's a slut.

MAGGIE: You're not a slut.

CORINNE: Oh honey, I am.

MAGGIE: You're not. You're not at all. And if I'm disappointed, it's only in your taste. He was old enough to be … you're a fox. You could get someone much fitter than that … much younger. *(Pause.)* I understand.

CORINNE: You shouldn't have to … I don't want you to understand. I want you to be oblivious … I want you to be ignorant of … to be pure … innocent … I want you … I want you not to be damaged … I want to not have damaged you.

MAGGIE: I'm fine.

CORINNE: Your mother's such a fuck-up.

MAGGIE: Please don't … I'm okay. I know about sex. I know a lot more than you … perhaps … give credit for.

CORINNE: *(Smiles.)* Of course. You're not a little girl. You're not a child. I never wanted for us to be a 'mother' and a 'daughter' … never wanted that … wanted us to be more like sisters … bestest ever friends. I never wanted you to look at me how I look at my mother … an old woman. I had it all worked out … what I'd say when I found your first pack of cigarettes … the first time a boy made you cry … when you came to me on your first period. I swore I'd never patronise. I'd be there for you and we would be friends. I was picking up some clothes off your bedroom floor … not snooping … not a snooper … there was an unopened tampon in amongst the laundry … there was a half-empty box in your bedside cabinet. And you hadn't come to me. You'd grown up without me. Muddled your way through on your own. Without my help … my advice. It broke my heart a little. And sex … I was going to be so open about sex … so you wouldn't make the same mistakes … assumptions … believe the old superstitions. But I've left it too late … and now … when you walk in on … something like that … and of course I've been keeping it dirty and secret. But again you've muddled through on your own … you seem to have known for … you seem unshocked. It's another thing I've missed … another thing I've … It seems I don't know you at all.

MAGGIE: Mum …

CORINNE: But I don't. Not really. I don't even know if you've had your first kiss. I don't know anything.

MAGGIE: What do you want to know?

CORINNE: I … just … some *detail* … about your life … your friends …

MAGGIE: Detail?

CORINNE: I just want to make sure you're alright. What are you like … when not around me? Are you … bolshy?

MAGGIE: Bolshy?

CORINNE: Are you extrovert?

MAGGIE: Mum …

CORINNE: There are some things … teenagers … some things a daughter can't-or-won't tell her mother. I understand and it's fine … I respect that. But I want to know that you're okay. And that you're happy.

MAGGIE: I am.

CORINNE: Do you have a boyfriend? What are your favourite subjects? Have you started drinking? Do you smoke? What about drugs? Are you well-liked at school? Are you bullied? Are you a bully?

MAGGIE: What do you want me to say?

CORINNE: I'm not going to punish you … I just want to know.

MAGGIE: I … don't smoke.

CORINNE: Okay.

MAGGIE: And … I … I like the work of HG Wells.

CORINNE: Are you sexually active?

MAGGIE: I … er … no. No.

CORINNE: Fine. Thank you. *(Hugs her tight.)* Friends?

MAGGIE: Friends.

11.

A street in Woking.

KIPH, in charity-worker tabard, handing photos to MAGGIE. She isn't looking at them.

KIPH: … and that one … this one … some as young as six … boys and girls …

MAGGIE: I don't …

KIPH: … and this one … Romania … Estonia … Latvia … it's becoming more and more common … more accessible for these …

MAGGIE: I'm not interested in …

KIPH: … this guy … has maybe fifty kids … on his books … and caters for …

MAGGIE: Kiph …

KIPH: … all kinds of … despicable … eight … nine … ten-year-olds … on his books … street kids …

MAGGIE: Stop it. I don't want …

KIPH: … abducted from their parents … or even exploited by their parents … it's becoming a thing of tourism …

MAGGIE: I don't want to know.

KIPH: I'm really not supposed to talk to friends while working … so if you don't mind just … looking at some …

MAGGIE: So we're still friends then … are we?

KIPH: Well … you know … acquaintances. Trafficking has become –

MAGGIE: Will you just talk to me?

KIPH: I don't want to … I don't know what you're going to say. *(Finds another photo.)* Bucharest … Riga … takes on a different meaning … kids hanging around on street corners …

MAGGIE: *(Fishes around in her pockets for change.)* How much?

KIPH: What?

MAGGIE: Just one pound a month, yeah? *(Holds out some change.)* I've got three pound fifty-six. Take it. The poor little sex-slave kids need it.

KIPH: *(Takes it.)*

MAGGIE: Now can we talk?

KIPH: Do you want a sticker?

MAGGIE: No.

Silence.

KIPH: I'm sorry. For freaking out. For doing what I said other men would do and I wouldn't. For running away. But I want you to know … I'm trying really hard. I'm spending my time trawling through the internet … hoping to find something that says it's all alright … that explains how your … fetish … is something normal – healthy. I'm hoping I'll find an article by an eminent psychologist or by some leading evolutionary scientist to explain it away but all I seem to be doing is learning Japanese. The thing is … rationally … logically … I can't see anything wrong with … your tentacle thing … because who does it hurt? But I'm still disgusted. I still see it as perverse … as properly perverse.

MAGGIE: That's how you see me?

KIPH: That's what you are, isn't it? I can't look at you. I just see squirming … writhing … wriggly things. Suction cups and black ink. I can't see past that. Not yet.

Silence.

MAGGIE: I walked in on my mum having sex. I left school early … went home … she had a guy in his pants with a gag in his mouth dangling from a hook in the ceiling. *(Gets out her phone.)* Do you want to see?

KIPH: No … no, thank you.

MAGGIE: She keeps a suitcase under her bed … full of sex toys … buttplugs and anal beads.

KIPH: Why are you telling me this?

MAGGIE: Who else am I going to tell?

KIPH: Can't you just ...?

MAGGIE: Keep it to myself?

KIPH: No. Not that. No. *(Pause.)* I believe that human desire is a vibrant and diverse ... tapestry? ... and people should be free to express themselves however they want ... and that people should be tolerant of difference ... and accepting of all sexualities ... but I can't help thinking ... there's a niggle rooted somewhere ... somewhere near the disgust clusters of the brain ... which tells me believing this is just defending ... protecting ... the sickos and the perverts. How do I get round that? Should I get round that?

MAGGIE: I could really do with a friend right now. I really need you not to judge me.

KIPH: I've got to get back to work.

12.

Horsell Common – nighttime.

MAGGIE's dancing has been interrupted by BEHROOZ's arrival.

MAGGIE with earphones in her ears.

BEHROOZ with a telescope and his sketchbooks under his arm.

MAGGIE: Hello.

BEHROOZ: Hi. *(Pause.)* Are you ...?

MAGGIE: Am I ...?

BEHROOZ: ... well? Are you well?

MAGGIE: Yes. You?

BEHROOZ: Better now ... seeing you. Can I ...? *(Raises his hand to her face.)*

MAGGIE: Sure.

BEHROOZ: *(Places his palm along her jaw.)*

MAGGIE: *(Takes his thumb into her mouth.)*

BEHROOZ: I haven't stopped … unable to … eat … sleep … thinking of you …

MAGGIE: *(Releases his thumb, clings to him.)* Hello.

BEHROOZ: Hi.

MAGGIE: I've bought you a present. *(Pulls out a book in a plastic bag.)*

BEHROOZ: *(Opens it, it's 'The War of the Worlds'.)* Thank you.

MAGGIE: You can't live in Woking and not have read 'The War of the Worlds'. Will you show me Mars again?

BEHROOZ: Can't … cloud cover. *(Pause.)* Your mother … my maps … you knew who I was, didn't you?

MAGGIE: Yes.

BEHROOZ: So you already had an idea …

MAGGIE: Yes.

BEHROOZ: Not some stranger in the dark?

MAGGIE: No.

BEHROOZ: It wasn't as spontaneous as … but that doesn't … diminish …

MAGGIE: Tell me about Mars.

BEHROOZ: I … it's … what do you want to know?

MAGGIE: Tell me about the surface. Tell me how we'd live there.

BEHROOZ: How we'd live …? The average temperature is minus sixty-three.

MAGGIE: We'd have to wrap up warm.

BEHROOZ: Well … yeah.

MAGGIE: What else?

BEHROOZ: I … er …

MAGGIE: Tell me what it would be like … so I can imagine.

BEHROOZ: Okay. Sure. There's a crater … an impact crater … in the Canadian High Arctic … Devon Island. It's

freezing but dry. Tundra … barren … it's the most Martian landscape on Earth. NASA sends a group of scientists up there for months at a time to live as though they were living on Mars … in a little caravan that doubles as a spaceship … eating rehydrated foods … carrying out experiments … testing equipment … spacesuits. Only ever stepping outside in spacesuits. That's what Mars will be like. You can watch them online … the astronauts … they have a webcam. You can watch them eating noodles or playing cards.

MAGGIE: No. Tell me – what would it be like for us?

BEHROOZ: I'm not sure I … okay, okay … for one thing, there'll be dust. An incredibly fine iron oxide dust. That's why she's red … she's been untended for so long she's turned to rust. This iron oxide … each individual particle is so small … so fine … as to be able to find its way through every material. We may be sealed in our spacesuits all day but we'd still need a shower to wash off the muck. And gravity … our bodies would have to adjust to the gravity … the planet is smaller, about a third the size … point three eight of Earth … so we'd be bouncing around like … bouncing people.

MAGGIE: Where would we live?

BEHROOZ: Live?

MAGGIE: Describe our home.

BEHROOZ: Our spaceship would have to serve as a base on the surface to begin with … but as we expanded … as we required more room we'd find ourselves a crater … a crater we could construct a roof for … so that we could actually walk on the surface barefoot. We'd have a favourite spot with our backs against an ejecta formation where we'd eat noodles under pink sky.

MAGGIE: 'Ejecta formation'?

BEHROOZ: Rock … around the rim of an impact crater. When a meteorite collided with the surface – millions of years ago – rock that had been melted by the impact would have

been thrown into the atmosphere … molten … and as it fell back to the ground it would've cooled … forming a teardrop of rock … solid. We'd sit beneath these tears and stare at our more distant sun … smaller … dimmer … less harsh on the eyes.

MAGGIE: *(Holding back tears.)*

BEHROOZ: Are you … what's the matter? What is it?

MAGGIE: I want to go … I want to strap on a jetpack and – whoosh! – travel so fast I leave myself behind.

BEHROOZ: Come on … it's alright …

MAGGIE: I don't want a father figure.

BEHROOZ: I wasn't trying to –

MAGGIE: *(Starts undoing his belt, his flies, gets down on her knees.)*

BEHROOZ: Okay … okay … I was thinking maybe … we could go back to my flat … not that … not that this isn't … nice.

MAGGIE: You can film me, if you want.

BEHROOZ: What?

MAGGIE: On your phone. You can film me.

BEHROOZ: No … um … you're alright … thanks for the offer though … thanks all the same …

MAGGIE: *(Stops.)* I … perhaps … do you mind so much … if we don't?

BEHROOZ: No … it's fine … sure … it's …

MAGGIE: Do you love me?

BEHROOZ: In what way?

MAGGIE: Will you take me to Mars?

BEHROOZ: Um … right … okay.

MAGGIE: Will you?

BEHROOZ: Yeah … sure … why not.

MAGGIE: You've got the maps.

BEHROOZ: Yes, I do.

MAGGIE: You know the way.

BEHROOZ: Sure.

MAGGIE: *(Picks up one of his sketchbooks, finds a picture of a crater.)* We'll live here ... this'll be our home. Put a roof over the crater.

BEHROOZ: Well ... that's ... that's the Hellas Impact Basin ... its diameter is one and a half thousand miles.

MAGGIE: We're going to go.

BEHROOZ: To Mars?

MAGGIE: To Mars.

BEHROOZ: Right.

MAGGIE: You don't believe me.

BEHROOZ: I used to think I would one day go to Mars. It didn't seem that far off. We were all supposed to be living on the moon by 1999. Where's my robot-butler? Where's my hoverboard? I don't think we'll get there ... not really ... not normal people. Scientists might ... it'll end up a scientific outpost like Antarctica ... but it won't be for people like you and me.

MAGGIE: You don't think I'll get there?

BEHROOZ: No.

MAGGIE: You won't take me?

BEHROOZ: How could I take you?

MAGGIE: What do you know about me?

BEHROOZ: What do I know ...?

MAGGIE: What do you like about me?

BEHROOZ: What do you want me to say?

MAGGIE: I don't mind that you like me because I'm young. That's fine. I don't want you to know me ... I just want you to love me. Better that there are blanks to fill in ... to fill in with whatever it is ... whatever it is that excites you.

I love your maps. I love you for your maps. I don't need anything else. Take me to Mars.

BEHROOZ: I can't.

MAGGIE: It's a real place … with real rocks … real sky … a solid place … an actual place.

BEHROOZ: We can't.

MAGGIE: Why not?

BEHROOZ: Why not?!

MAGGIE: We just need a spaceship.

BEHROOZ: *(Gathering his stuff.)*

MAGGIE: Where are you going?

BEHROOZ: Home. *(Beat.)* Is that what you think of me? That I only like you because you're young?

MAGGIE: Was there something else … something else you liked about me?

BEHROOZ: Thanks for the book.

MAGGIE: *(Takes his sketchbook and tears the picture of the Hellas Impact Basin from it.)*

BEHROOZ: Don't do … don't do that!

MAGGIE: Our crater … sat under teardrops … eating noodles … staring at the sun …

BEHROOZ: I'm going to … go. I'm going to go. This is me leaving. *(Exits.)*

MAGGIE: *(Alone.)*

13.

A bar in Woking.

CORINNE and JOHN sitting at a table with a bottle of wine.

JOHN toying with the photo of his unborn child.

CORINNE: You called me. You said you wanted to talk.
(Pause.) No? Well then. *(Stands, downs her wine and starts to exit.)*

JOHN: Please.

CORINNE: *(Sits.)*

JOHN: Do you want another … or shall we … I thought maybe your house … or … travelodge. The way we left things … you said … if I ever change my … and I have … my mind … if I ever change my … I have.

CORINNE: So have I.

Silence.

JOHN: *(Puts the photo down, takes off his wedding ring and his watch, gets out his mobile phone, he makes a neat pile of it all in the centre of the table.)* My kid … my watch was a birthday present from … I've got a load of pictures of my wife on my phone … that's it … that little pile … that's everything … everything good that's ever happened to me. I'm an achiever. I have achieved. *(Beat.)* Did you ever see that … that cartoon … I can't remember … what was it … something … you've got this character … who was it … and there's this big button … big red button … and he's … oh god, who was it … and there's this sign above … on the wall above … and it reads 'do not press the red button' … and … the character … looks at the button … looks at the sign … looks around to see if anyone is watching … looks at the button … looks at the sign … looks around … looks at the button … presses the button. And this trapdoor opens up beneath him and he falls … to his … I don't know … 'doom'. *(Laughs.)* It's hilarious. I mean it's properly funny. God, who was it? Do you remember … did you ever see …?

CORINNE: I don't …

JOHN: No. Oh but it was classic.

CORINNE: I think you should go home. Kiss your wife.

JOHN: Yeah, yeah, I should.

CORINNE: Marriage isn't a walk in the … you've got to work at it. It won't just look after itself.

JOHN: I'm sorry?

CORINNE: You can't let things slide … you've got to talk it through … don't bottle it all up … you've got to resist the temptation to run away. I'm sure your wife –

JOHN: Please don't talk about my wife … my relationship.

CORINNE: Is married life not what you … not what you expected?

JOHN: It's better.

CORINNE: Really?

JOHN: Yeah. Yeah. Truly. I love my wife a great deal. She loves me. We've got a kid on the way. I couldn't … I couldn't be happier.

CORINNE: Then why are you … here? Why did you call me?

JOHN: You should be flattered.

CORINNE: I'm not going to sleep with you.

JOHN: I don't need you to protect me.

CORINNE: I'm not protecting you, I'm protecting … there's only so many times … risks … times you can … before it starts seeping into the other aspects of your life … you start hurting people … it's not worth … I've been lucky. You're about to become a father, for fuck's sake.

JOHN: You should be flattered … what I'd risk … for you.

CORINNE: Not for me. You don't know me.

JOHN: No.

CORINNE: So why would you?

JOHN: Pulling at the loose thread … making a hole. Because I can. Because it's there. Because part of me wants to see it all come crashing down.

CORINNE: *(Picks up his phone and tosses it at him.)* Delete my number.

JOHN: *(Does.)*

CORINNE: And you've got my business card.

JOHN: *(Fishes it from his wallet and hands it to her.)*

CORINNE: *(Takes it back.)* You're not to call me again.

JOHN: So we're not … travelodge?

CORINNE: I'm going to go home … spend some time with my daughter. *(Goes to exit.)*

JOHN: *(Stops her.)* You run a gallery. On your business card it says you run a gallery. Here in Woking. What sort of stuff do you exhibit?

14.

Horsell Common.

RICHARD and MAGGIE.

RICHARD: I … er … do you remember … strung up … naked … yeah?

MAGGIE: I'm not likely to forget.

RICHARD: No. You've got … on your phone … you took pictures. I want them erased … destroyed … deleted.

MAGGIE: I want doesn't always get.

RICHARD: Would you … please? *(Beat.)* Are you … alright?

MAGGIE: Just a little … out of place. *(Holds out her picture of the Hellas Impact Basin.)*

RICHARD: *(Takes it.)* What's this? Is that … is that Mars?

MAGGIE: Yeah.

RICHARD: I know Mars. *(Hands it back.)* It's a nice picture.

MAGGIE: John Carter. I thought I'd seen you before.

RICHARD: I don't make a habit of … what you walked in on … that's not me.

MAGGIE: I'm going to Mars.

RICHARD: Yeah?

MAGGIE: Got any advice?

RICHARD: Er … don't breathe the air.

MAGGIE: Thank you.

RICHARD: I've got a son … about your age … couple of years older. Old enough to gallivant to the other side of … un-chaperoned. He's on a gap year. Thailand right now – Bangkok. Or at least should be … according to his … itinerary. I wouldn't know … he doesn't … hasn't been in contact. I don't care about the money. What was it … thirty quid? You keep that. But the photos … on your phone … they may not seem much to you … bit of a laugh … show your mates … bit of a giggle … but it's the sort of thing … uploaded to a social networking site … can end up as … page five of a freesheet … faded celebrity … tittle-tattle … may not seem much …

MAGGIE: Do you like being strung up?

RICHARD: No.

MAGGIE: Why did you let her do it then?

RICHARD: Seemed the thing to do.

MAGGIE: Would you say she was sick?

RICHARD: What? No. It's fine … just wasn't very me.

MAGGIE: Would you say she was approaching sick?

RICHARD: I … it just wasn't very me.

MAGGIE: What is you?

RICHARD: Everyone's got a kink, I suppose. Some people like shoes. I've never understood that … the shoe fetish. I just think odour-eaters … corns and verucas. But for some

people … which is … fine … of course it's fine. Each to their own.

MAGGIE: What's your kink?

RICHARD: I don't think I want to …

MAGGIE: Why are you here? Out on the common?

RICHARD: Why is any old man on the common at night? I don't know what I want.

MAGGIE: *(Shows him the pictures on her mobile phone.)* I could delete them. If you would like.

RICHARD: Could you just … please … my relationship with my son is fragile. I don't want … any reconciliation … any move on my part … to be drowned out by his cries of 'hypocrite, hypocrite'.

MAGGIE: How does this make you a hypocrite?

RICHARD: I called him a pervert … my son … just before he left. He's gay. He left some websites open … on my computer … images … links … forums … gay-chat. I think he wanted me to find them … easier than actually talking about … I called him a pervert. The things they were discussing. His mother was the only woman I ever … and she … when he was three … she … and I haven't … not once … since. So I've never been particularly … adept at … never discussed … because I wasn't coming from a position of authority … of experience. It was never … broached … as a subject. Sex. His bags were already packed … I was supposed to take him to the airport. He never logged-off … never signed out … there wasn't the chance between … shouting … name-calling … the front-door-slam. After he'd gone … messenger services … I left them running … open … on the desktop. There'd be … every once-in-a-while … there'd be a little electronic noise … suchandsuch had logged in … soandso was now online. They left … suggestive … dirty remarks … what they'd like to do to me … not me – my son … missing the sweet taste of his … I wanted to ignore … but also … I wanted to understand. So I responded to one of them … just to … get

inside the mindset, I suppose … and we were … chatting … this guy … young guy … just chatting. He described … in all kinds of detail … how he'd … in my mouth … all over my … in my hair … and then he asked if I was hard … asked if I was masturbating. And I said 'yes' … because it was true. *(Beat.)* I logged-off … signed-out … deleted the history file … ran all the virus checks … wiped everything … reformatted. Clean. As though it hadn't happened. But I can't … not think about … can't not … which is not right … because I'm straight. I registered … signed up with … a heterosexual site … because that is what I am … I'm a fifty-two-year-old man looking for a woman between the ages of thirty-five and fifty within a ten-mile radius of my postcode. *(Pause.)* I just want to tell my son that I love him … without … any of … anything else … overshadowing.

MAGGIE: *(Hands him her mobile phone.)*

RICHARD: *(Fiddles with the phone.)* How do you … delete …?

MAGGIE: *(Takes the phone back, shows him as she deletes the photos.)*

RICHARD: Thank you. You're a good kid.

15.

CORINNE's gallery.

KIPH is in full fancy-dress; two extra limbs, upward pointing tusks, loincloth, green bodypaint and a rifle slung over his shoulder.

BEHROOZ to one side.

CORINNE on the phone.

BEHROOZ: He looks absurd.

CORINNE: She's not picking up.

BEHROOZ: He looks like a prick.

KIPH: Maybe her battery's dead.

CORINNE: *(Puts away her phone.)*

BEHROOZ: He looks like an arsehole. Did you hear me?

CORINNE: Yes I did. He looks like a prick. I get it. Okay?

BEHROOZ: When does it run?

CORINNE: Tomorrow.

BEHROOZ: Call them. Call them and say you've changed your mind.

CORINNE: I'm not going to do that.

BEHROOZ: You could've asked.

CORINNE: I could've.

BEHROOZ: You knew what my reaction would be.

CORINNE: It's publicity.

BEHROOZ: It's cheap.

CORINNE: It'll be on the front page …

BEHROOZ: … of the local rag … the local …

CORINNE: It has a circulation of six and a half thousand.

BEHROOZ: It's got nothing to do with my maps … absolutely no relation to what I … to what I'm trying to …

CORINNE: He's a Martian.

KIPH: I am Tars Tarkas – chieftain, Jeddak and King of the Green Martians.

BEHROOZ: You're a prick – a prick in fancy-dress.

CORINNE: There's no need for –

BEHROOZ: Mars does just fine without so much as a micro-organism. The whole point is that these are massively empty landscapes. There's no life here – it's too cold, there's too much salt in the ground, too much carbon dioxide. There are no little green men with bulbous eyes and grinning jaws.

CORINNE: Will you just –

BEHROOZ: These canvases are blank and if you can see canals or the layout of an ancient city or a creepy face peering back at you from the bedrock … well that's your imagination.

CORINNE: Barsoom, I'm not trying to –

BEHROOZ: That's not my fucking name! *(Pause.)* I'm not trying to be precious … I'm not trying to be difficult … I understand compromise … I understand that when you get what you want … in actuality … it's never going to be … *(Beat.)* I'm sorry. I'm being an arsehole. I appreciate … I really do … all you've done … all you're trying to do … but it's not how I imagined.

CORINNE: It's a hook … to get them through the door. And once they are … once they stand in front of your maps … they'll get lost … drawn in. Like I have done. Like my daughter has.

KIPH: They are pretty cool maps.

BEHROOZ: Thanks. You're right. I'm sorry.

Silence.

KIPH: Does Maggie have a favourite? I thought I could … buy her one … if she likes them so much.

CORINNE: I don't think that would be appropriate.

BEHROOZ: But does she? Have a favourite?

CORINNE: That one.

KIPH: *(Reading a label next to the painting.)* 'Approaching Pavonis Mons by Balloon'.

CORINNE: We were in here the other day … I was all hither and thither … letting things get on top of me … she thought it would cheer me up if she … if we took a trip to Mars. We turned off the lights … and in the dark … the screen of her phone … we passed the beam slowly over the acrylics and the oils … standing so close to them that everything … even in our peripheral … all we could see was Mars. We stared into it … not just at, but through the canvas … for miles … like we were flying above the surface. We must've stayed like that for half an hour … on a different planet … away from … away from any … and we were laughing at how silly … how childish we were being. She's an absolute angel … despite her mother … and I don't deserve her.

BEHROOZ: She said to me that they were like bloodclots … like a capillary had burst in your retina and turned everything red. I thought it a strange description … but beautiful … which is appropriate, I suppose … from her. Strange and beautiful.

CORINNE: When was this?

BEHROOZ: Last week.

CORINNE: When did you … have you met my daughter?

BEHROOZ: Er … yeah.

CORINNE: Because I haven't introduced you.

BEHROOZ: You must've done … when was it … it was … yeah, yeah … you … you did.

CORINNE: No. I didn't.

BEHROOZ: It was you … and me … and you said 'this is my … this is Maggie …'

CORINNE: No. No.

BEHROOZ: You remember … of course you do.

CORINNE: Where did you meet her?

BEHROOZ: It was … where were we? It was …

CORINNE: Where did you meet her?

BEHROOZ: It was … on the common … I remember now … that's it … you're right, you weren't there … I had my telescope … she saw I was making maps of … must've put two and two together and …

CORINNE: On the common?

BEHROOZ: Yeah, yeah.

CORINNE: When was this?

BEHROOZ: Last week.

KIPH: Are you the guy?

BEHROOZ: What guy?

KIPH: With the wide black eyes and the leathery brown skin?

BEHROOZ: I'm sorry – what?!

KIPH: The guy on the common … who she meets … are you him?

CORINNE: What have you been doing with my daughter?

BEHROOZ: I … I …

16.

CORINNE's gallery.

Darkness.

The breaking of glass and the opening of a door.

A figure moves in the darkness, taking the canvases off the wall.

The light is switched on.

KIPH, still in fancy-dress, stands by the lightswitch.

MAGGIE, caught in the act, with several paintings under her arm. Her eyes are wild and wide, she is filthy, there is something animalistic about her. Her hands are particularly dirty, her fingernails have all been pulled away, as though she has been frantically digging with her bare hands.

KIPH: Hello.

MAGGIE: Why are you dressed like that?

KIPH: Publicity shots … local paper. What you doing?

MAGGIE: *(No answer.)*

KIPH: Been trying to call you.

MAGGIE: Switched my phone off.

KIPH: Your mother's worried … out looking … can't find you.

MAGGIE: Don't want to be found.

KIPH: You shouldn't switch your phone off.

MAGGIE: Don't want to answer it.

KIPH: Where are you taking those?

MAGGIE: I need them. *(Beat.)* I'm going to Mars.

KIPH: You can't.

MAGGIE: Why not?

KIPH: You're crap at maths. Astronauts are all mathematicians.

MAGGIE: Why are you here?

KIPH: Thought it would be empty? That why you broke in? Make it look like a robbery?

MAGGIE: It is a robbery.

KIPH: Your mum asked me to … in case you showed up.

MAGGIE: And now I have, what are you going to do?

KIPH: He won't love you … your grubby sex-time-on-the-common fella … with his maps. Not like I would. He's not going to understand you.

MAGGIE: I know that. And you do?

KIPH: I think I've got a fair idea. I've been familiarising myself with … accumulating every last … I get it. It's about erotic threat … inevitability … sexual helplessness and hunger. Concepts of bondage and rape … surrendering yourself to a sensation. There's something primordial … terrors of the deep … the creatures that chased us out onto the land … a desire to be dragged back to a simpler evolutionary state. You want to be helpless … because life's so much easier without choice. You want to be a slave. It's the exotic and the bestial and the wrongness. And, as I'm playing here … some sort of internet-educated Freud … I'm going to say that I think that it stems from a fear of childbirth. It's a terrifying concept … mingling your DNA with someone else's. You lose yourself a little. It's common in science fiction … the alien-human hybrid. Spock's mother was human. It's the birds and the bees and the freaky half-bird, half-bee monstrosity that could grow in your gut. It's about the phallic facehuggers laying eggs in your belly and then an alien bursting from your chest. But it's human … it's natural … and ancient … krakens and medusas. It's not weird it's just … difficult … for someone who doesn't … get it … to understand. I tried to explain this … to my Dad … because he walked in on me … tentacles on television.

So now he thinks that's what gets me off … what floats my boat … that I fantasise about being pinned down by a many-limbed sexbeast from outer space. I didn't even bother arguing … I let him believe it … I encouraged him to believe. We watched it. 'Legend of the Overfiend'. He's pretty liberal … he's pretty good really … and we sat there for … until about halfway through. And though he said that he couldn't get a handle on why anyone would be aroused by it … he did say that he admired its … artistry. *(Pause.)* So now I'm like you. Because I can't really … take that back.

MAGGIE: I can't believe you did that.

KIPH: I know!

MAGGIE: Kiph …

KIPH: You won't be able to hide it … if you're ever in a long-term relationship … these things'll come out. But I already know … and I'm here. I ran away … but I came back. I still love you. What other man would do that?

MAGGIE: *(Starts to cry.)*

KIPH: *(Looks at her hands.)* Your nails … pulled away … what've you been doing?

MAGGIE: Digging.

KIPH: We should get you cleaned up.

MAGGIE: No. No time.

KIPH: *(The canvases.)* What are you going to do with them?

MAGGIE: I need to find somewhere … I need to … escape. *(Pause.)* I'm so fucking disgusting.

KIPH: I don't mind.

MAGGIE: You know Mars … you know Mars, don't you? Look at you … look at you … you can come with me … if you'd like.

KIPH: Where are you going?

MAGGIE: *(Pulls out her picture of the Hellas Impact Basin.)*

KIPH: It's a long trip. We're going to need supplies.

17.

CORINNE's gallery.

The walls are now empty, stripped of the paintings.

BEHROOZ is reading his copy of 'The War of the Worlds'.

JOHN in the doorway.

JOHN: The door was open. The window was broken. They took everything?

BEHROOZ: Yeah.

JOHN: Have you called the police?

BEHROOZ: No.

JOHN: Why not?

BEHROOZ: I don't know.

JOHN: We shouldn't be here … contaminating a crime scene.

BEHROOZ: *(Dismissive look.)*

JOHN: Sorry. *(Pause.)* Are your pictures worth something then?

BEHROOZ: I guess. To someone.

JOHN: I would've liked to have seen them. I would've liked to have … supported …

BEHROOZ: You're here to support me?

JOHN: Yeah. *(Takes the picture of his unborn child from his wallet, shows it.)* See the little fingers … the toes …? That's a little life right there. *(Beat.)* Give me your phone.

BEHROOZ: *(Does so.)*

JOHN: *(Types a number and hands it back.)*

BEHROOZ: What's this?

JOHN: Phone my wife.

BEHROOZ: I'm not going to phone your wife.

JOHN: That's her mobile number.

BEHROOZ: Why would you want me to?

JOHN: There should be no secrets in a … in a …

BEHROOZ: Then you do it.

JOHN: You were going to … you threatened to …

BEHROOZ: I don't understand why you're here.

JOHN: Don't call her in a week … don't call her when the baby's born … call her now.

BEHROOZ: I don't …

JOHN: Like a plaster, yeah? Like a plaster. *(Pause.)* Do it.

BEHROOZ: *(Makes the call.)* It's engaged.

JOHN: Leave a message.

BEHROOZ: No. Leave it alone … with any luck I'll forget –

JOHN: I don't want you to forget. I want you to be angry. I want you to be disgusted. I want you to be outraged. I would be … I am.

BEHROOZ: I can't be outraged all the time … I can't …

JOHN: I'm a bad man. I think bad thoughts.

BEHROOZ: I'm not going to argue. Do you love your wife?

JOHN: So much.

BEHROOZ: Then why do you want to hurt her?

JOHN: I don't … but I'm going to. It's inevitable.

BEHROOZ: Does she love you?

JOHN: She adores me. *(Pause.)* It was fan-fiction … what I downloaded. It was fan-fiction for a franchise I'm not even remotely interested in. I'm not saying that to excuse it … I'm not saying that to … but it wasn't … it was pretty dark, I understand that … schoolgirls … exploitative … demeaning … but still fiction so I … I thought it was harmless … *(Pause.)* I would rationalise it … you start thinking about sex when you're thirteen anyway … so your first sexual … your first lust … was for … and I'm British … so sixteen is fine … sixteen is … and the age of consent

elsewhere … it's a cultural thing and you have to take that into account … Portugal is fourteen … Mexico is twelve … and I'm not … I'm not *that*. But there is no universal …

BEHROOZ: In Yemen the age of consent is nine.

JOHN: Fuck off.

BEHROOZ: But you have to be married.

JOHN: It's all normalised, isn't it? You can see … if you're looking. Slutty schoolgirls in pop videos … pigtails … fellating lollipops. Movie starlets … popstars … the tabloid words used to describe them … 'blossoming' … 'womanly curves' … 'coming of age'. It's a constant low-level hum. All implying that it's acceptable … that there are others thinking as I do. But a monster in a pack of monsters is no less of one. *(Beat.)* I met my wife at School Disco … that clubnight you dress up in school uniform … how fucked up is that? Every time she touches me … every time she traces the ridges of my ear with her finger … or draws my hand down to the swell of her belly … I'm terrified she's going to see something … discover that filthy bit of grit at the heart of who I am. It's going to happen and I'll have to face it. So I'll do it on my terms, thank you very much. Call her. Please. Get it done.

BEHROOZ: No.

JOHN: No?

BEHROOZ: I can't … I …

JOHN: You can't?! Just a moment ago you –

BEHROOZ: You should just … be silent. Be a husband … be a father … be a cartographer and be silent. *(Pause.)* I think I've done something … pretty bad … think I've … the girl I've been … I don't think she's …

Pause.

JOHN: How old?

BEHROOZ: Sixteen.

JOHN: Sixteen?

BEHROOZ: She says.

JOHN: 'She says'?

BEHROOZ: She says.

JOHN: 'Accuracy isn't everything'? *(Beat.)* Give me your
phone.

BEHROOZ: *(Does so.)*

JOHN: *(Makes a call.)* Hi honey. Yeah, it's me. I'm on my way
home now. Yes. Tonight. Should be back … ten … half ten.
Okay. I'll see you later. Love you lots. Bye bye. *(Hangs up.)*
How do you … how do you delete …?

BEHROOZ: *(Takes the phone and deletes the number.)*

18.

The sandpit on Horsell Common – nighttime.

*KIPH is digging a hole. Still in fancy-dress, he is stood in a crater a
couple of feet deep shovelling away. His green body paint is dripping
off with sweat.*

MAGGIE is hugging the canvases to her chest, clinging to them.

CORINNE is opposite MAGGIE, worried and tired.

CORINNE: I have been so worried.

MAGGIE: Why are you here, Mum?

CORINNE: Maggie … please … don't run off … don't … I'm
not angry …

MAGGIE: I don't want you here.

CORINNE: Did he … did he …?

MAGGIE: No … I …

CORINNE: Did he hurt you?

MAGGIE: I'm not … I'm not who you think I am … what you
think I am …

CORINNE: It's okay … it's okay … it's not your fault … you
haven't done anything wrong …

MAGGIE: How do you know that?

CORINNE: You're an absolute angel and I love you.

MAGGIE: I'm not … I'm not …

CORINNE: You've done nothing wrong.

MAGGIE: I'm leaving … Kiph and I are leaving …

CORINNE: Whatever it is … we can work through it … we can … you don't have to run away …

MAGGIE: I was the instigator. I was willing.

CORINNE: *(Gets out her phone.)* I'm calling the police … I'm calling …

MAGGIE: I'm a slut.

CORINNE: You're not. You're not at all.

MAGGIE: Everyone knows it … everyone says so. It's always on the edge of everyone's breath … in the flick of their eye … even the teachers know it …

CORINNE: What are you saying?

KIPH: It's true. Everyone knows it.

MAGGIE: People say it … people know … it doesn't matter what happened … what physically, actually happened. It's the easiest thing in the world to be what everyone says you are. I'm disgusting … I'm vile … repulsive … repugnant … degenerate. I'm sick.

CORINNE: You're not … you've just been a little … you've just … made some mistakes …

MAGGIE: *(Grabs CORINNE by the arm and pulls her down into the crater.)* Can you feel that? It's warm. Why would it be warm?

CORINNE: I … I don't know.

MAGGIE: There's something under here. Something giving off immense heat. Something pulsing and vibrating. Something buried. And I fuck men on the warm patch … I fuck them … I let old men touch me … I let them in me … I let them … a slut can't say 'no', can she? A 'no'

from a slut has as much weight as air. And then it climbs … it climbs out from the ground … breaks through the mantle and climbs up their arsehole … and it takes them over … it takes them over while they're in me. Their skin stretches and breaks … their spines arch … veins pulse with angry blood … tentacles rip through me … rows and rows of sharp little teeth … they're monsters … I'm fucking monsters … and I want them to stop … I want them to stop … but I'm wet … I'm so wet … and though a part of me is screaming, another part … a stronger part … is going 'do it, do it, harder, deeper, fuck me, fuck me, fuck me'.

Silence.

CORINNE: How many …?

MAGGIE: Does that matter?

CORINNE: How many?

MAGGIE: I had a boyfriend … I thought I had a boyfriend … at school … two years above … three weeks and … three weeks … and then … *(Beat.)* Said that I was filthy … all his friends … told them I was … *(Beat.)* And so I was. *(Pause.)* And then Behrooz … and maps … and noodles under the lukewarm sun …

CORINNE: That's …?

MAGGIE: Yeah.

CORINNE: Two?

MAGGIE: Yeah.

KIPH: *(Crosses to MAGGIE.)*

MAGGIE: Don't touch me … don't touch me …

KIPH: *(Hugging her tight.)* We're going to dig up this ship … this cylinder … and escape. We're going to find ourselves a new civilisation … where people don't know us … where we'll fight monsters and save the world … and it'll be our world … ours … we're going to … we're going …

MAGGIE: *(Squirming away.)* No … no … no … I don't want … I don't want …

KIPH: We'll reverse the polarity … we'll phase-induce the tachyon pulse. I'm going to be with you. And you're going to be happy.

MAGGIE: I don't want … I don't want …

CORINNE: Kiph …

KIPH: *(Lets her go.)*

MAGGIE: *(Picks up the spade and starts shovelling away the earth, but it's not immediate enough, she's throws herself down and starts clawing at the ground with her hands.)*

CORINNE: Maggie … Maggie … please … stop it … just … please. *(Desperate.)* Maggie! What the hell are you doing?! There's nothing down there!

MAGGIE: There is … there is … it's warm … it's warm and alive …

CORINNE: There's no spaceship … there are no aliens.

MAGGIE: Has to be … has to be … otherwise … otherwise that just makes me …

CORINNE: Can't you see how ridiculous … how nonsensical you're being?

MAGGIE: It's here … it has to be here … otherwise … otherwise … I …

KIPH: Maggie … it's … not … never was …

MAGGIE: *(Stops digging, looking at the bodypaint that has rubbed off on her clothes.)* You've got green on me.

KIPH: Sorry.

MAGGIE: I'm just … oh …

CORINNE: You could've told me … you could've … I was here to listen … we're best friends, aren't we? Friends tell each other everything.

MAGGIE: You're not a friend. You're barely a mother. You string up strangers in the family room … you keep your anal beads where any nine-year-old can find them.

CORINNE: *(Starts to cry.)*

MAGGIE: Is it because you're ashamed … because it's shameful? Why else would you keep it secret … locked up … tucked away in a tatty leather suitcase under your bed? I hate it … I hate it … I hate … feeling … why do I feel … why do I want … why do I want to find some stupid spaceship with some slimy, greasy, otherworldy monster … some beast without a heart … why do I want that? Why do I want that inside me? What's wrong with me?

Silence.

KIPH: *(Picks up the spade and starts digging again.)*

CORINNE: Kevin … could you … leave that. *(Beat.)* Your mum will be worried.

KIPH: Just a little deeper … there might yet be … it is warm …

CORINNE: Leave it.

KIPH: I'll stay if that's alright, Mrs Radd.

CORINNE: She doesn't need a friend, Kiph.

KIPH: *(Nods and exits.)*

Silence.

MAGGIE: *(Arms out, needing a hug.)* Mum … I'm sorry … I'm … Mum …

CORINNE: *(On the verge of hugging her.)*

BY THE SAME AUTHOR

SALT MEETS WOUND
ISBN 9781840027525

Dylan Singer needs to leave London. With his alcoholic ex-fiancée he heads to Central Asia, to research the book he's always dreamt of writing. But it's 2002, the height of the 'War on Terror', and Uzbekistan isn't the belly-dancing opium den he is expecting.

From 11th century Samarkand, through the Great Fire of London, to a disused weapons facility in the remotest place on earth, *Salt Meets Wound* is an epic odyssey spanning a thousand years.

WWW.OBERONBOOKS.COM

Follow us on www.twitter.com/@oberonbooks
& www.facebook.com/oberonbook